*PROFESSIONAL*

# WEDDING
## PHOTOGRAPHY

*TECHNIQUES AND IMAGES
FROM MASTER PHOTOGRAPHERS*

Lou Jacobs Jr.

AMHERST MEDIA, INC. ■ BUFFALO, NY

Copyright © 2009 by Lou Jacobs Jr.

Front cover photograph by Stacey Kane.
Back cover photograph by Dane Sanders.

All rights reserved.

Published by:
Amherst Media, Inc.
P.O. Box 586
Buffalo, N.Y. 14226
Fax: 716-874-4508
www.AmherstMedia.com

Publisher: Craig Alesse
Senior Editor/Production Manager: Michelle Perkins
Assistant Editor: Barbara A. Lynch-Johnt
Editorial Assistants: John S. Loder and Carey Maines

ISBN-13: 978-1-58428-239-6
Library of Congress Control Number: 2008926654

Printed in Korea.
10 9 8 7 6 5 4 3 2 1

# CONTENTS

# INTRODUCTION

### Valuable Images

When Hurricane Katrina decimated the U.S. Gulf Coast, floodwaters gobbled up many treasured photographs. A woman digging herself through mud and debris in Mississippi was heard screaming when she unearthed her wedding album. The prints were faded, warped, and streaked, but some were salvaged by Operation Photo Rescue, digital experts in Pass Christian, MS. They charged no fee, but I think you have to be a catastrophe victim. That hurricane proved again that when fire and other disasters threaten, a family first saves children, then photo albums and pets.

Everyone is sentimental and possessive about personal photographs. That fact inspires a lot of wedding and portrait photographers who realize how much their images will be valued, now and in the future. So it's understandable that couples are willing to pay well for wedding pictures. Clients trust professionals to deliver memorable images they will guard well.

### Cool Photographers

Experienced wedding photographers stay cool at a wedding. They soothe brides to help boost their confidence when the weather turns hostile, or people show up late, or maybe they get the jitters. In *Chickweed Lane,* a comic strip I read, both bride and groom said their legs stopped working as they approached the altar. As a wedding shooter you learn to face your own glitches without panic. In fact, you are able to stay mentally sharp during the whole wedding day. Awareness fuels your personal motor drive.

**The Experts.** All ten contributors to this book are successful wedding shooters, each with a sense of how to get along smoothly with clients and wedding guests. Their advice and anecdotes will help you anticipate what clients want and happily pay for. Each photographer shares his or her own approach to capturing hundreds of highlight moments during a wedding day.

The backgrounds of these experts are diverse. A few worked on newspapers, some are self-taught, many studied photography, and all offer opinions and ideas. Some have studios but rarely use them because weddings are

*Photo by Dina Douglass.*

photographed on location. Their opinions differ on topics such as scouting wedding sites, using assistants, or how much retainer fee to charge. Their offices are often at home. They have experienced shooting at churches, social halls, sandy beaches, on ships and boats, in handy parks, and private clubs. Many photograph destination weddings in foreign countries.

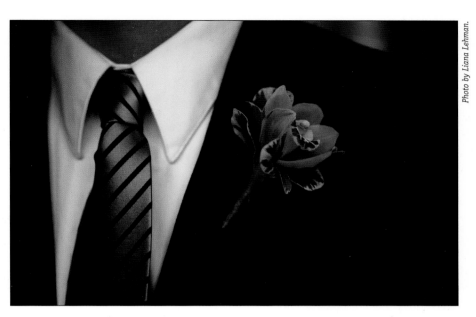

*Photo by Liana Lehman.*

### *Photographic Style*

I asked each contributor if wedding photographers can or do develop personal, recognizable styles. I found that views vary. Some say personal style is necessary for success. Others believe individual styles are often hard to distinguish. Most wedding photographers can be artistic reporters and interpreters when they work deftly to capture decisive moments; they think graphic images, not style.

Style may be largely in the eye of the beholder, but here's my definition: style emerges from an instinct for individuality, from a sense of timing and from talent for design and composition, plus a sense of color and form. You can be a excellent photographer with an elusive style.

Intertwined is the ability to identify with the bride, groom, and maybe a cast of characters. Success can be built on style that enables a photographer to apply perceptive seeing to photo opportunities. Style also depends on your capturing the advantages of lighting, expression, and action. Bright sun, moody indoor or outdoor light, and variations of those can add glamour, drama, or pensiveness to images. Study the ways photographers in this book have handled light and timing. Look at paintings in museums and galleries to help increase your sensitivity to light, shadows, and composition.

### *Rapport and Attitude*

An aptitude for developing rapport with brides, grooms, families, and wedding guests should be part of your repertoire. Contributors to this book all seem to share the joy of weddings that become pageants of music, dancing, dining, and drinking. At the celebration, take delight in the crowd that creates a sort of a sideshow. Later, in a laptop slide show, you may present moments when the bride, groom, and their admirers are having a grand time.

### *Learning Options*

- Some photographers advise studying pictures by other wedding photographers for inspiration. Others say not looking at competitors' work enables you to develop your own approach to weddings. As the king in *The King and I* said, "It's a puzzlement."

- Many photographers make a habit of studying art books, fashion magazines, documentary images, and the work of cinematographers.

- As for creating wedding timelines, some say they "go with the flow" after discussion with the bride and groom, and maybe a wedding planner. Others generate timelines to synchronize with the bride.

- In most chapters photographers mention their cameras and lenses, but none says that any brand or model is essential to success, because it's not. You should create pictures with whatever equipment pleases you.

- Lifestyle photography indicates little posing. When someone shows off, it's part of the day's entertainment and you shoot. Lifestyle photography is domesticated photojournalism, when you look for off-guard activity. Photographing a wedding can be like photographing a news event.

## Some Covered Topics

The pros interviewed for this book have a great deal of experience to share. Among the topics they address are:

- Mentors and other influences
- Preparing for weddings and scheduling
- Retainers, fees, and contracts
- Promoting your business
- Presenting pictures to clients
- Using assistants or working alone
- Selling albums, prints, and enlargements

## Shooting and Business Tips

Each expert makes suggestions for taking pictures and offers ideas for good business practices. You may also study techniques in their photos. How-to information and emotions pop out of the images. Notice lighting arrangements, posing, settings, facial expressions, and creative settings. My group of experts wants to teach, and you will learn to photograph weddings smoothly and profitably.

There are two great web sites devoted to the triumphs and tribulations of wedding photographers: www.ilovephotography.com and www.digitalweddingforum.com. They are loaded with ideas and contacts, and you may make new friends.

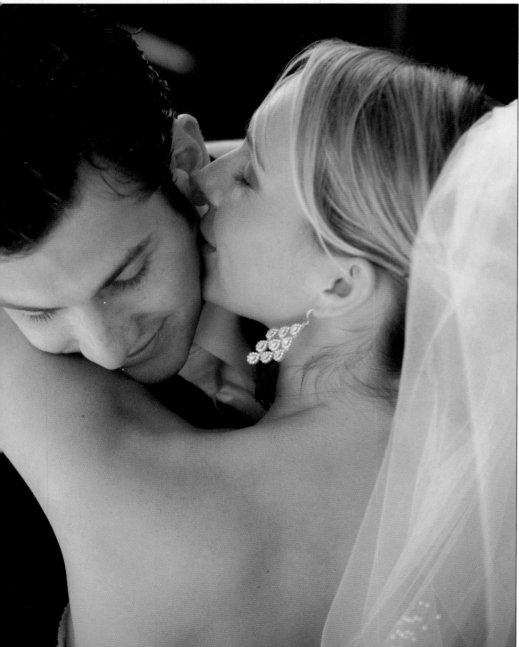

*Top—Photo by George Weir.*

*Bottom—Photo by Dane Sanders.*

# 1. JEN AND STEPHEN BEBB

*www.bebbstudios.com*

In 1999, Jen and Steve Bebb of Vancouver, BC, Canada started in business as Tying the Knot Wedding and Event Photography, and when they moved from a home office to a new studio in 2007 they re-branded as Bebb Studios. They work as a team at weddings and intermingle their edited images. Twenty photographers asked this role-model pair to do a private four-day "Bebbinar," in 2007 at which they covered the skills needed by successful wedding and portrait shooters. The Bebbs were featured in the March/April 2007 edition of *American Photo* among the ten best wedding photographers in the world. Jen is the speaker here.

**Describe your background.**

We both took amateur photography courses. I started at age ten, and Steve studied through high school; however, we are also self-taught. At university my degree was in political science and international relations. Steve's interest revived when I bought him a camera one Christmas, and he took more classes. In 1999, he photographed weddings for several friends, though our focus was in buying houses, fixing them up, and selling them. When I picked up the second camera at a wedding and made some images that stopped me cold, I was hooked.

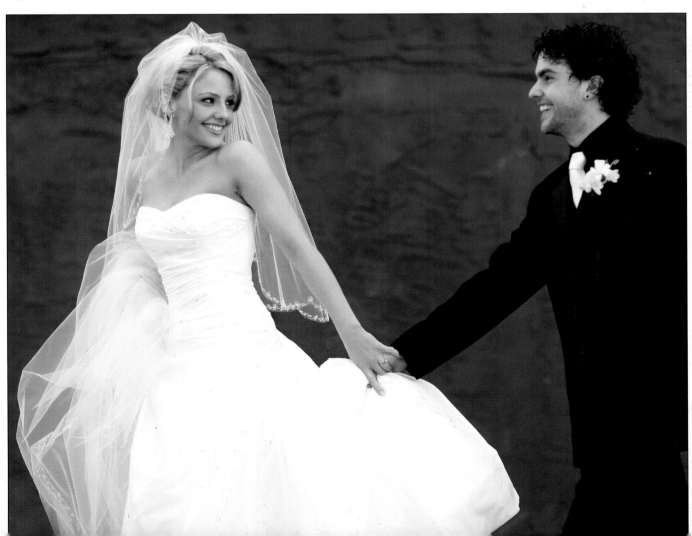

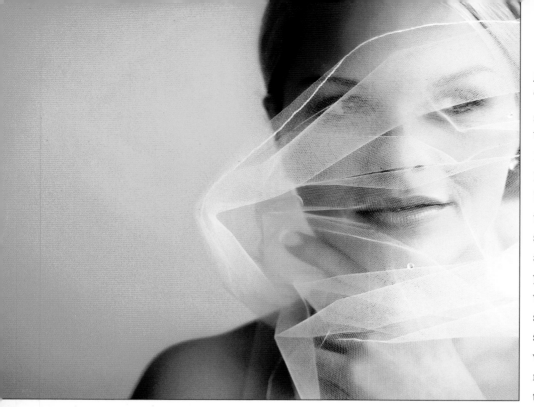

### How is your career evolving?

To shoot weddings part time we started business as Tying the Knot Wedding and Event Photography in 1999. We still had full-time jobs, and I was pregnant with our first child, but by January 2000 we moved full time to wedding photography. Our son was born two days before we got a spot in a local bridal show, and that year we happily booked thirty-five weddings. Bookings grew to forty the second year and increased in subsequent years. After shooting seventy weddings one year, we realized we needed to review our business. By then we had a second child and our

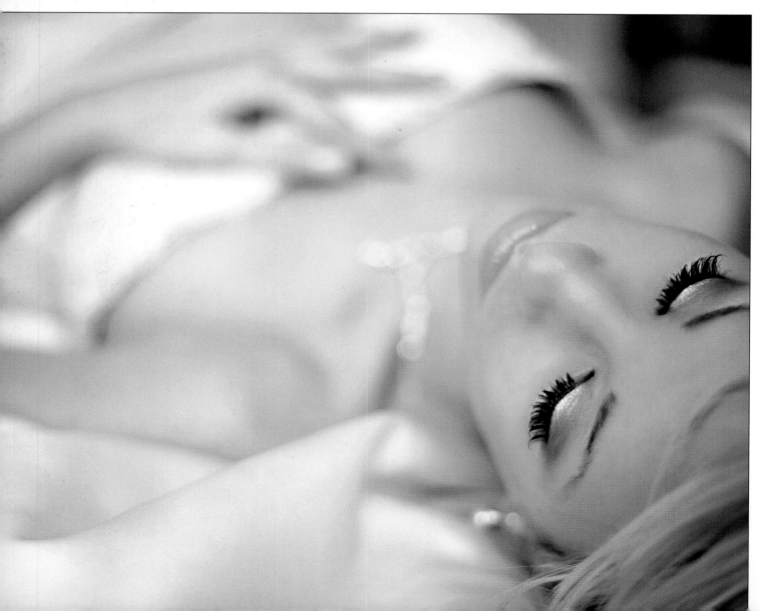

clients were starting to have babies, so portrait requests were pouring in, and we shifted from only weddings to portraits as well.

We were among the first in our market to shoot exclusively 35mm. Steve is stronger than me technically, but I learned to hold my own. Rather than trying to merge styles, we have seen them become more distinct as we each discover what moves us. With a new studio [described later], we hope to eventually do twice as many portraits as weddings.

### Who are your influences and mentors?

Our business grew so quickly that we had little time for seminars or looking at other photographers' work. We had not been thrilled with the photos from our own wedding, and we understood the importance of great wedding images. So we found our own way through experience, personal efforts, and our passion. Plus, we have always taken our cues from clients and are photographically inspired by their relationships.

We attended the Digital Wedding Forum (DWF) convention in March 2005 and hosted David Williams at our studio that fall. Those two events lit a fire under us to continue being better than we were. I consider many people we met at the convention to be mentors—most notably JVS and Becker. David Williams has been an ongoing source of support, and we feel fortunate to be among his students. Since that convention we have built relationships with many of the industry's best, all of whom inspire us with their generosity and openness.

### Describe your studio and office.

We once worked from a home office with a space outside our home to meet clients. In 2007, we opened a new studio in a 1926 building. One of its major draws is its bank of north-facing front windows. We are natural light photographers and use supplementary lighting only occasionally. The studio is about 800 square feet and was remodeled with space for our office work. It has a projection room, a sales rooms, a generous shooting space, a private office, and a reception area. The basement is currently used for storage but will ultimately be utilized for production. We have a studio manager who is unbelievable, and we hope to add a production person soon. Having a full staff will help us keep relatively regular hours.

### How do clients find you?

A large percentage of our clients come to us via e-mail, from direct referrals, and many brides have already planned to hire us. We suggest that contacts e-mail us so none of us has to take notes. We explain what we do and how we can all work together. Later, we try to meet with local clients, and we chat by phone with out-of-towners who hire us about 95 percent of the time.

The main topics clients discuss are pricing and packaging. We explain the number of hours we'll be at the wedding and what they get for our fee. They review albums and make choices. Wedding budgets have become larger in our experience, and though we have raised our prices substantially, our season is always booked.

For local weddings we are familiar with most venues, and we often travel to our favorite spots for photos, rather than staying at the ceremony or reception areas. For destination wedding clients, we always arrive two days before the wedding to become better acquainted with our couple and to scout locations.

### Describe your approach to scheduling sessions.

We book weddings from eight to twenty-four months in advance. When we have already booked a weekend wedding, we carefully evaluate booking another one. Weddings are almost always on weekends, but we do three or four mid-week weddings each season.

All dates are entered into Successware; we also keep a hard copy of each contract saved on the computer. We use iCal to sync our calendars across all our computers. In addition, we have a white board where wedding dates are posted along with a schedule of portrait sittings, travel, and speaking engagements. We track production in Successware as well as on the white board.

### How do you handle retainers and fees?

To hold the date we charge 40 percent of the package amount. The low retainers we charged in our first year made us uneasy because they are not hard to walk away from. On the other hand, a nonrefundable retainer of $2000 to $4000 is a substantial investment. We are sympathetic to the plight of clients whose wedding is called off, but we will only return a portion of the retainer, minus an administrative fee, if we can rebook the date.

We have worked with many pricing models and have stuck with one based on the number of hours clients will need. Proofs are no longer included in any packages; files are only included with an album. Otherwise, files are for sale at a premium.

When we travel, we charge a flat fee that includes hours of coverage, al-

bums, files, travel costs, hotel fees, etc. We have one rate for North America and another for Central and South America and the rest of the world. We found the flat rate is more effective for us because clients know from the start what to expect.

### How do you address the need for contracts with your clients?

We explain that contracts protect both the photographer and the client. Important stipulations in our contract cover prices including overtime rates, a payment schedule, how long a price will be held, rescheduling of the event, cancellation of the event, liability to both parties, and a clear outline of our mutual obligations. The details of each contract are entered into Successware, as are

changes made via e-mail. These are also added to iCal to help us organize our business.

### Do you shoot locally or at more distant locations?

We shoot both, but more local weddings each year. We limit the number of destination events to zero between June 30th and September 15th when our kids are out of school. During the summer we do photograph about twenty local weddings.

We meet clients who customize weddings without apologies or compromises. However, we still shoot many that follow "typical" wedding guidelines. The trend is having fewer guests but a better-quality experience.

Location shoots are not easy to sell. We charge a premium, and our services become a fairly expensive part of

the wedding. However, we are getting our quota of weddings each year.

### How do you handle your travel arrangements for location shoots?

We make our own travel arrangements online or with a travel agent. The equipment we take on location includes two Canon 5Ds and two Canon 20Ds bodies, five prime lenses for me, a zoom, and four prime lenses for Steve. My favorite is an 85mm f/1.8. Steve's current favorite is the 17–40mm f/4. We also bring a video light plus a Lowell ID light and small SunPack strobes. We like the drama using hot lights for fill can create, even when just a little bit of fill is needed.

### What is it like to work as a team?

Steve and I efficiently divide our responsibilities. Steve is better at chatting with people in person and better at workflow. He is in charge of all phone calls, engagement sessions, and of fine-tuning images. He also meets with other vendors in our market. I'm in charge of all scheduling and initial edits, album design, e-mail, and researching new products.

At weddings we shoot independently with a few exceptions. I'm a more emotional photographer, so I cover the speeches and other such moments. He works with the bride. During family photos I organize groups and Steve photographs them straight on while I shoot other angles. We also take different positions during the ceremony and reception, each of us covering must-have shots

with freedom to be creative. We are rarely in each other's way, and we're often happily surprised at what the other has shot. The key is knowing where the other person is during the day.

### Do you have any tips for handling the unexpected?

Unexpected events and moments often provide great photo opportunities. From the flowers that never arrive to the clergyman who's ninety minutes late, there are many variables. We face the unexpected by being constantly aware. We try to sense changes in the atmosphere. I watch body language and expressions. Being ready to catch such moments is the hallmark of a professional wedding photographer. Though some guests expect it, we rarely share what we've shot on the LCD. We might show an image or two to the bridal party, but they realize how little time we have.

### Describe your photo timeline.

Our contract specifies the amount of time we require for photos, which is not difficult to get in our market. We are expensive, and the people who hire us value what we do. We cooperate with couples to facilitate their timeline, a skill we've developed while shooting more than three hundred weddings. We've developed an instinct about allocating time for different activities.

### Do wedding photographers have recognizable styles?

All good photographers have a recognizable style, which is an important reason why clients choose them. Our photographs show a consistent stylistic thread that becomes the catalyst for clients' booking us. Clients expect similarly distinctive results on their wedding day.

Clients also recognize that we are artists, and on their wedding day they encourage us to push ourselves and

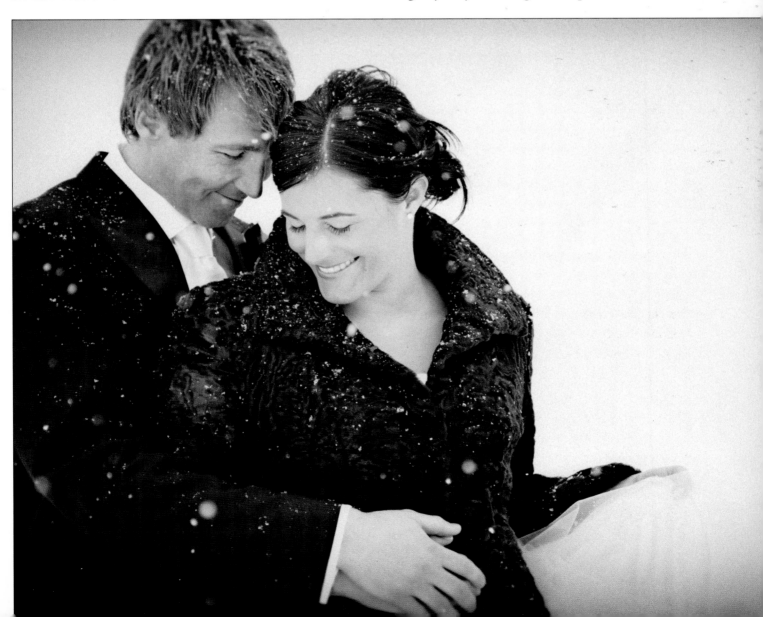

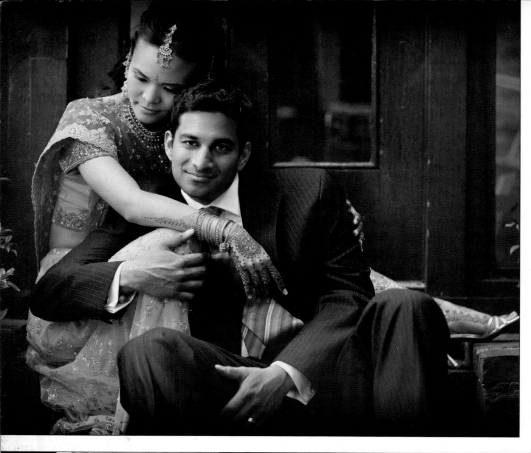

them. To increase our impact, at each wedding we include time to shoot subjectively for ourselves, and those images are often the most moving because they are inspired by our subjects in ways we can't duplicate. So consistency and artistry define our style to set us apart in our market.

### How do you approach lighting your subjects?

We use off-camera flash and/or video lights when the situation calls for it. We have not yet used large strobes to cover larger areas, though we are experimenting with a flash on a stick.

### How do you handle your workflow?

Here is our 2008 practice: Memory

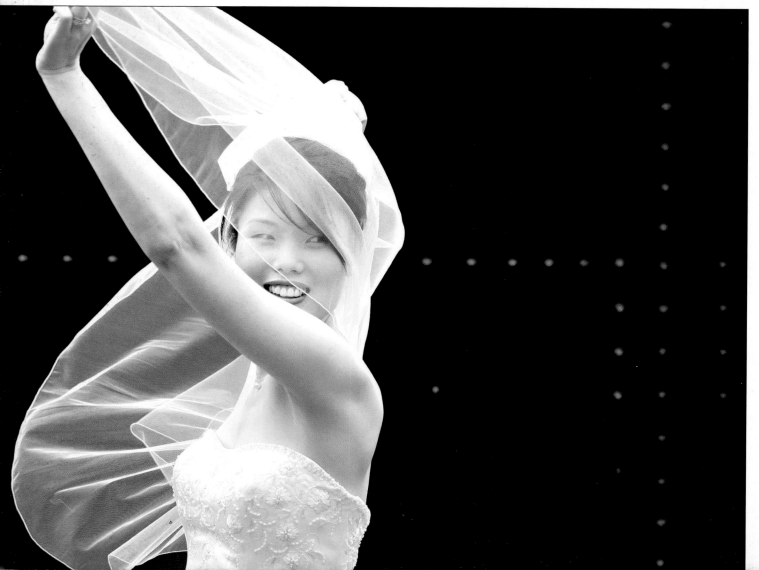

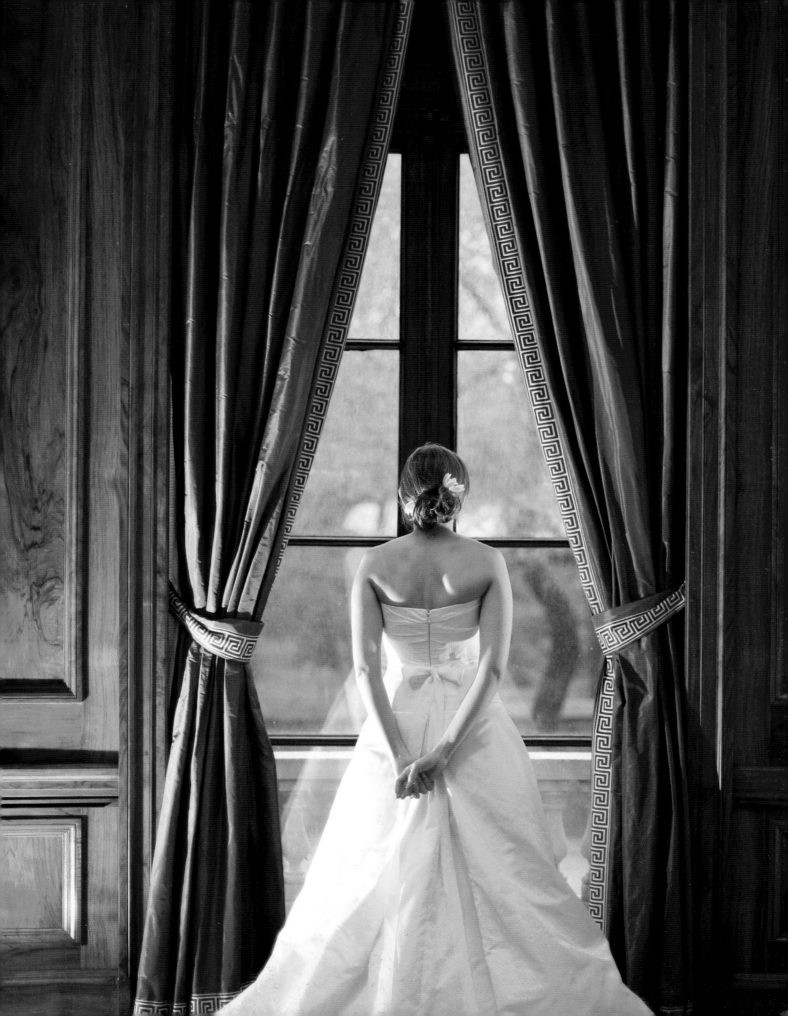

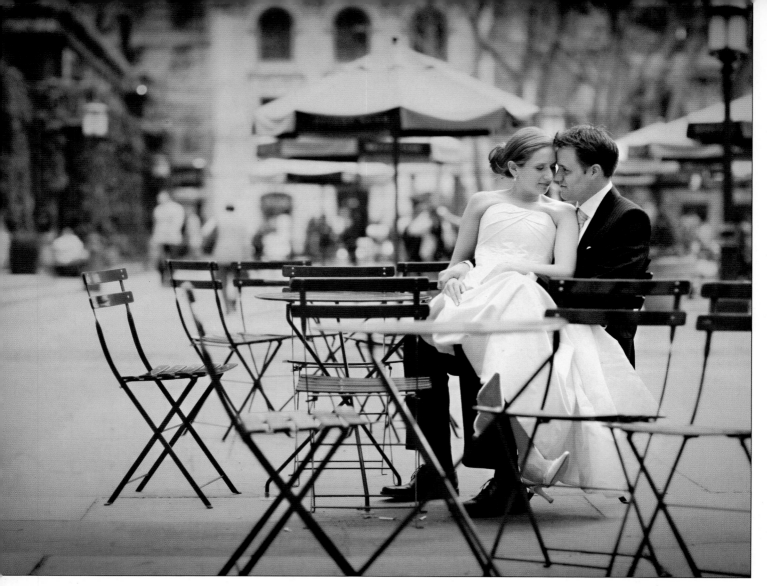

cards are downloaded into folders for each of us. We back up original files, rename them to differentiate my images from Steve's, and then we combine them. We use Photo Mechanic to tag all of the images we want to keep.

Ten to twenty images are worked on for our blog and a selection is posted. Tagged files are copied to another folder to be edited. We select 10 percent of my images, such as flower images, to be in color. A black & white action is run on the rest of my files. We use an autoloader script to go through every file and adjust it as necessary. At this stage we convert some of Steve's files to black & white. The full-resolution files are then burned to a DVD.

Our clients come in for a special slide show viewing, and they also see a predesigned album. The online gallery/shopping cart is uploaded, and clients are given access information at the same meeting. Out-of-town clients view their own online gallery.

At this point in the editing the final choice about black & white or color is made. Some of my images will be color and some of Steve's will be black & white. Clients expect to receive half their images in black & white and half in color. We're not super tight editors and sometimes keep images that are not technically perfect but advance the story. We try to keep the number of images for the client around seven hundred and fifty but may include more based on the day. For example, Asian weddings offer different photographic opportunities such as the tea ceremony or the toasting of tables at the reception.

### What do your packages include?

Only our time is included in current packages. Everything else is offered à la carte. We produce the albums using a minimalist design aesthetic. Prints on canvas, in all sizes, are proving to be very popular.

**How do you promote your business?**

Since most inquiries come from referrals, we don't need to promote our business aggressively. We are aware that there is sometimes a high client turnover, so we continue to run an ad in a local bridal magazine aimed at our clientele. We maintain our own web site and blog.

**Is there any business advice you'd like to share?**

Early on we made some good marketing decisions. We placed ads in every available publication and went to every possible bridal show. We started as a self-employed sole propri-

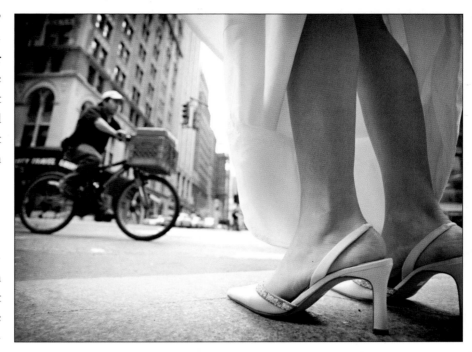

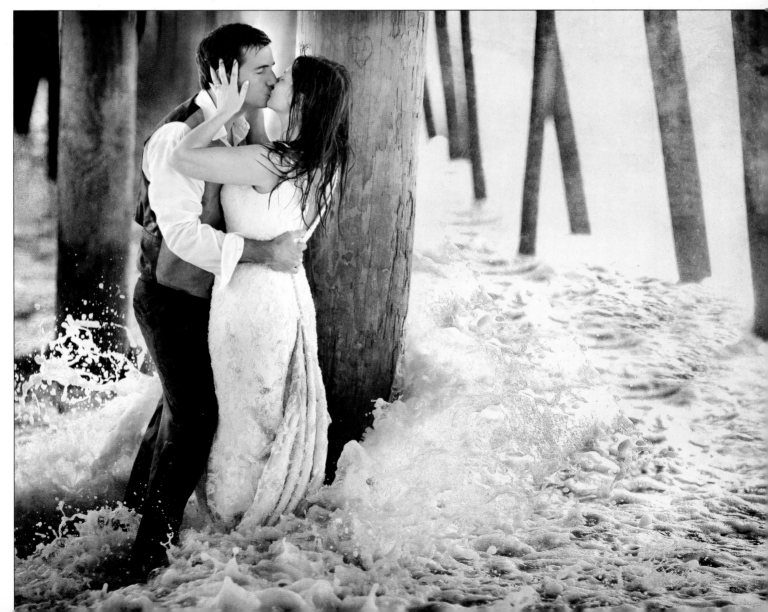

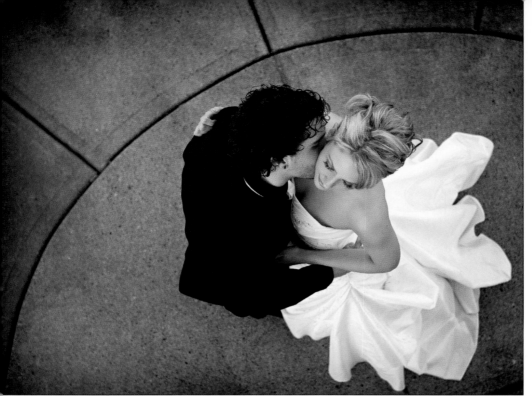

etorship and we have since incorporated. We pay ourselves a salary and keep business and personal expenses completely separate.

I'd guess some photographers fail because they overspend and they do not raise prices at proper intervals. Every company should have a business plan and should be well aware of its financial position. Photographers should outsource operations they believe will make them more efficient. A local lab does all our prints for us.

### Is there a philosophy that guides your wedding photography?

Steve and I approach weddings from different perspectives. From my more emotional view wedding photographs that excite me also please clients. I am drawn to what a moment says versus how it looks.

Steve's approach is more practical. He is an incredible beauty photographer, a skill that makes our brides look flawless. He is also able to stand back and observe, choosing his moments with care. He can shoot and appreciate emotional images with more technical awareness about what he's producing.

### What challenges do wedding photographers face?

It's all too easy to get caught up in what everyone else is shooting. I sometimes think that the popularity of on-line forums has hurt our industry as much as it has helped. Though we want to be familiar with cutting-edge techniques, it can lead to standardization. We try to develop a personal way of making images. Find what moves you and follow that path.

We grew from within and advanced our craft through ingenuity, not by imitating. Today, scrutiny from other photographers drives us forward in ways that we weren't driven before. We face a familiar challenge, to stay ahead of the pack, which results in constantly thinking, and evaluating, and growing. It's a position that we don't take for granted but are grateful for. We aim not to become complacent or comfortable, because we must always strive to be better.

Dina Douglass of Los Angeles, CA, does business as Andrena Photography ("Andrena" is her real first name). She has a background in newspaper and magazine photojournalism and has written and illustrated numerous articles for publication. She is active on several professional wedding photography web sites, including the Digital Wedding Forum, for which she serves as a moderator. She was also the subject of a *Rangefinder* profile I wrote a few years ago. Dina has a bubbly personality, a quick perception of myriad photographic possibilities, and also, seemingly endless energy.

**Describe your background.**

I studied photography in junior and four-year colleges, and won thirty-plus state and local awards for work published in college newspapers and magazines. Though I wanted to major in photojournalism, I switched to journalism to become an indispensable asset to publications. Little did I know that neither magazines nor newspapers let people write *and* create images for their articles.

**How has your business evolved?**

In early 2002, I decided to pursue wedding photogra-

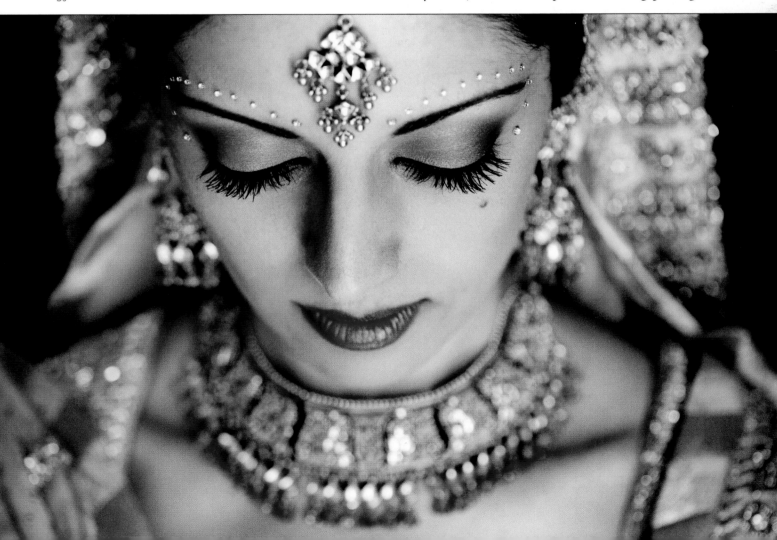

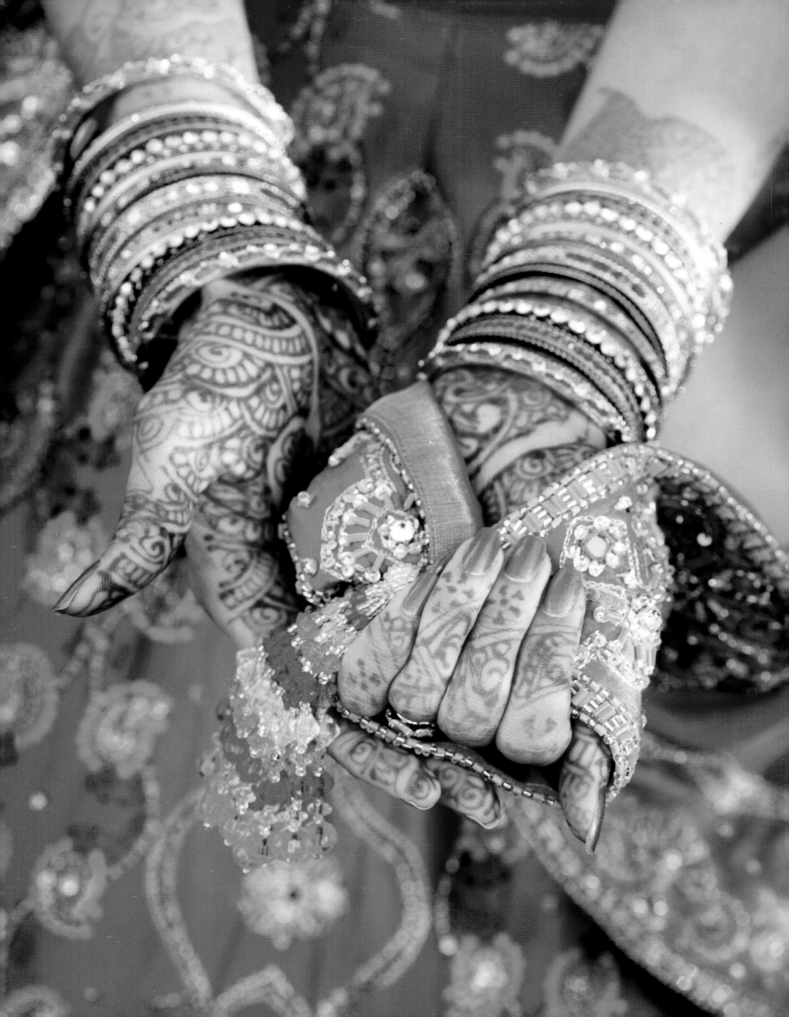

phy. I left corporate America behind and spent a year working for other people to ensure that I understood the ins and outs of weddings. In six years my prices have nearly tripled, and I now speak at conferences and write articles for various publications. I've done several magazine covers and have published all over the world. I went from being totally unknown to having a strong reputation in the profession.

### Who are your influences and mentors?

As a teenager I was fascinated by *Life* magazine photographers, and particularly, the *Best of Life* books. As an idealistic student, I aspired to be like the great photojournalists and documentarians, such as Margaret Bourke-White, Robert Capa, Mary Ellen Mark, and Gordon Parks. My early heroes also included Ann Summa and Gary Friedman, both of whom photographed punk rock. I also like Jim Marshall's work, particularly the shot of Johnny Cash flipping off his audience. I've long been a fan of George Hurrell's movie star portraits, and there's always something to appreciate in Mario Testino's soft black & white images. I like the high-concept images of David LaChapelle and Annie Leibovitz.

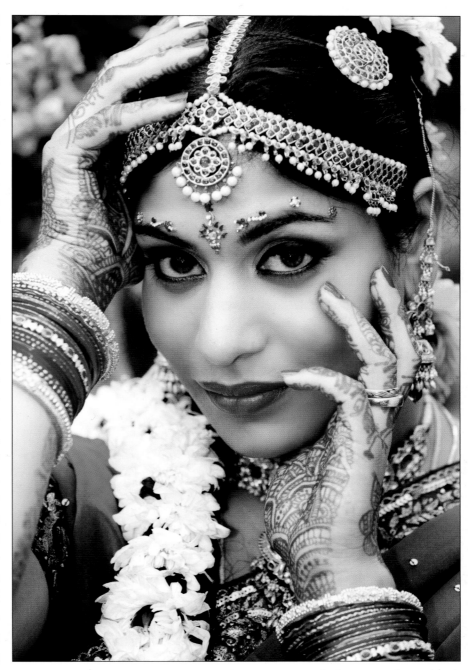

### Do you shoot locally or at more distant locations?

I tend to do more local weddings, but my international reputation has grown. My expertise in an array of multicultural arenas enables me to routinely field queries from potential clients who are based on various continents. In recent years I've done weddings in India, Indonesia, Mexico, and the British Virgin Islands. I recently spoke to a potential client about her wedding in Serbia. I never know where an inquiry might come from.

For location shoots, I generally have my clients book my airfare and hotel (provided I agree with the itinerary, of course). This saves me from having to invoice them later.

### Do you visit the site of the wedding before the event?

I do not usually have time to do site visits, but most of my clients understand that. When it's an unfamiliar venue, I usually go to the site early to look around, but it is rare that I encounter a site that I haven't already been to.

### How do clients find you?

There are five primary ways that clients find me: web site, blog, coordinators, word of mouth from past clients, and print ads. Future clients make their initial judgments about you and your work based on what they see on your web site, where how you present yourself makes all the difference between you and someone with deficient communication skills.

My blog is now visited by thousands of people each week. From some ethnic groups I work with, for instance in areas with large South Asian populations, I get huge amounts of blog traffic. Maintaining a blog is time-consuming, but the investment immediately pays off in added visibility and brand awareness.

Word-of-mouth is still a great advertising medium. Enthusiastic brides provide friends and relatives with endorsements that money can't buy. I make sure to reward my referring brides with nice thank-you gifts. Coordinators tend to have favorite vendors, and I have had much success in getting them to refer business my way. My work speaks for itself, but when a coordinator backs it up with an endorsement, I always book the client.

As the above categories of promotion have grown, I cancelled all my online advertising and print ads except one, an ad that's out in front of vendors, so they remember you and know you're still in business.

### Describe your approach to scheduling sessions.

This is relatively simple. When an inquiry comes in via phone or e-mail, I check the date on my bookings spreadsheet and if I'm available, I inform the couple by e-mail and ask if they want to set up a meeting. I prefer not to book more than one year prior to a wedding date, but I make occasional exceptions. I also participate in online calendar sharing with a number of colleagues, which enables me to direct referrals to people who aren't already booked and vice versa. I often shoot multicultural weddings that last several days, so I shoot on weekdays as well as weekends.

### How do you handle retainers and fees?

When a client signs a contract, I require one-third of the total package price as a nonrefundable retainer. The balance is due fifteen days before the wedding.

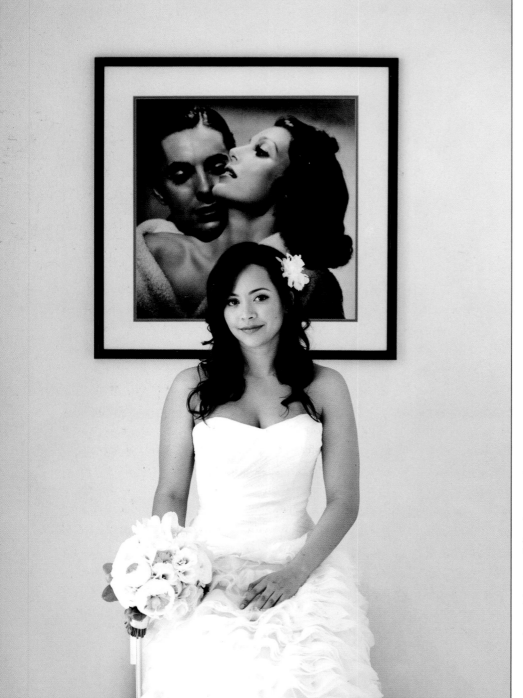

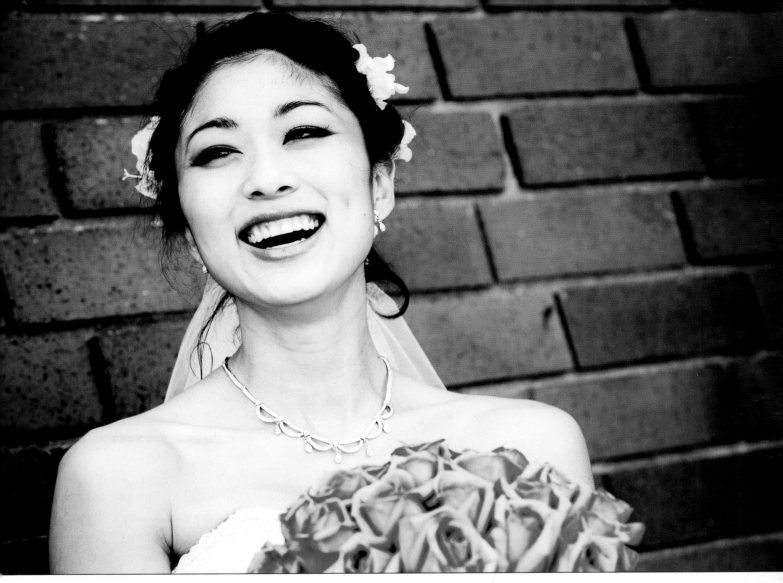

My parents spent $150 on their wedding, so I'm grateful that budgets have become larger. The amount that people expect to pay for photography varies greatly. Some couples think $15,000 is reasonable while others are unwilling or unable to pay more than $2,000. Couples in larger cities are often willing to pay more than those in smaller towns. But I do encounter many clients who try to negotiate.

For weddings that fit into the confines of my standard one-day packages, my regular pricing applies. But for multi-day South Asian weddings (Hindu, Sikh, or Muslim), I put together custom proposals, as each wedding involves a different number of days, hours, and album requirements. For all destination weddings, clients pay the package fee as well as travel and accommodation charges.

I currently offer five packages, ranging from one with no album for smaller weddings to my top package, which includes an engagement session, a large mounted print, a guest book, two photographers on the wedding day, a large custom wedding album, parent albums, a full set of 4x6-inch prints, an online gallery, and all the files after one year.

### What sort of things are covered in your contract?

Some of the most important clauses in my contract are "the limitation of liability," "the cancellation policy," and "the sole professional photographer at the event policy."

Limitations of liability are important. You do not want to lose your entire business due to a hurricane, accident, theft, or other act/event beyond your control. I contractually limit my liability to no more than the total package value, less expenses. This means that if I am robbed at gunpoint and all my memory cards are stolen, my total liability to clients would be a refund of their package price. It is also important to carry liability insurance, just in case.

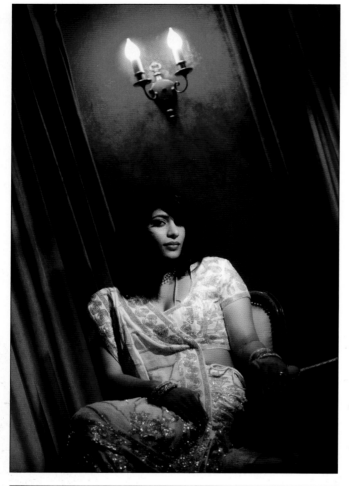

Like most professional photographers, I do not provide a refund when a couple cancels their wedding. At present, I do provide a refund if I am able to rebook the date with a package of equal or greater value. If I do provide a refund, I charge an administrative fee that covers time already spent with the client.

It's very important to clearly state that you will be the only professional photographer retained for an event. My "sole photographer" clause states that "any photographer with pro equipment shall be deemed a professional photographer, regardless of actual profession." There are occasions when another professional photographer has been retained, or an ambitious friend or relative tries to cover the entire event to build their portfolio. This creates a horrible headache for all involved, since everyone ends up jockeying for position. My contract states that if someone at the wedding becomes a nuisance, I can stop working until any interfering photographer puts their gear away.

### Describe your photo timeline.

I create timelines for all my couples and encourage all my brides to call me early in the process, before they set their hair and makeup appointments. That way I can set up a workable timeline to ensure that I have enough time to create the images they're expecting.

### What tools do you rely on to get the images you're looking for?

My studio is wherever I make it, be it in my garage, my home, or on location. Understanding lighting is key to being able to control any situation. Though I use backdrops for certain types of sessions, I prefer using elements in the area to frame my subjects. For studio lighting, I use either DynaLites or AlienBees monolights, with softboxes or umbrellas. But I'm just as happy creating images with window light. Portraits are an important part of any wedding coverage, and I require that my clients set aside "alone portrait time" so I can create the images they're expecting.

I shoot Canon cameras exclusively and have done so since I was twelve years old. I currently shoot with Canon 5D bodies, and a variety of L series and specialty lenses. My favorite lenses are the 70–200mm f/2.8 IS and the

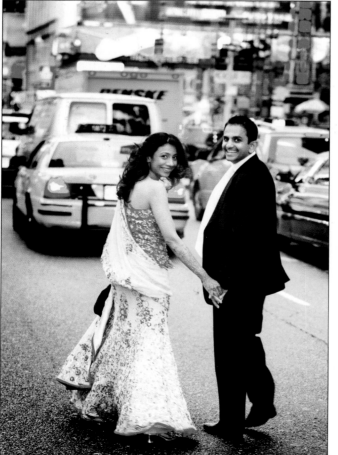

100mm f/2.8 macro. Lighting-wise, I can handle anything as long as I have two monolights, one umbrella, and two stands. I generally travel with AlienBees monolights, as they are small and easy to pack.

I use off-camera strobes for group shots and reception room lighting. In my opinion, several strobes add a dimension and quality that cannot be achieved with a single flash on camera or off.

### Do wedding photographers have recognizable styles?

I may be known for bright colors, beautiful sepia tones, unique portrait compositions, and my work with diverse multicultural clients. But precious few wedding photographers have a truly "recognizable" style. Some people may favor certain combinations of Photoshop actions, but unique visual ideas are usually copied within months of their original creation. At a certain level of capability, there's nothing new under the sun. If someone's a great shooter and Photoshop artist, this fact will be obvious to most people, and their prices will underscore their level of capability.

### Do you have any tips for dealing with the unexpected?

Weddings are uncontrolled events. The bigger they are, the more opportunity you have for something to get off schedule or go awry. I've built my reputation on being able to effectively handle massive weddings (with up to twelve hundred guests), as well as the lighting challenges and timeline issues that such large events often entail.

I do everything in my power to never be late. So if a wedding venue is an hour away, I will leave my studio

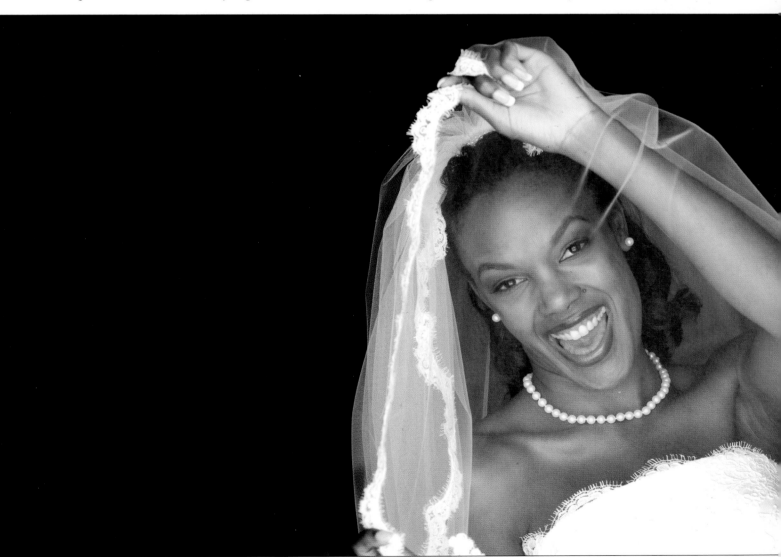

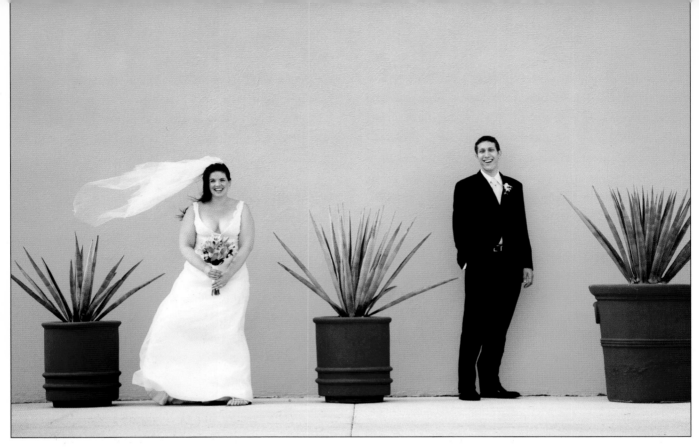

two-and-a-half-hours before I need to be at the event, just to be safe.

The biggest issues I encounter at weddings involve people who are not cooperating when I'm trying to do group shots and have a limited amount of time to get through all the families. Patience and being firm but friendly pay off.

### Do you book small weddings?

I can't easily give up a weekend day for a small job. If it's a small wedding planned for the upcoming month and I have the date open, I'm happy to accept it. I'll also serve as a second photographer for a colleague in a bind. I don't offer "budget" prices for couples who plead economic hardship, but for a reduced shooting time and less product, cost will be commensurate.

### How do you handle your workflow?

My routine is as follows:

• Download memory cards
• Back up all RAW files
• Create iView catalog
• Arrange images into shooting order
• Edit out rejects

• Rename selected files
• Burn selected photos to DVD
• Send DVD away for color correction, or correct in-house
• Receive XMP files after color correction
• Add XMPs to "selects" folder, then run JPEGs
• Choose images for black & white, sepia, and/or cross processing
• Run batch actions on each resulting folder
• Resize entire job down to 4x6-inch images and FTP to lab
• Pick up photos from lab and ship to client
• Post job online
• Ask client to send list of album choices
• Design album
• Post for review
• Make requested changes
• Make album prints
• Number pages and send to album manufacturer
• Deliver final album and files to client.

### How do you handle image presentation?

I present clients with a full set of 4x6-inch proofs first. After prints have been received, I send clients an online gallery. I separate these presentations because I find that

viewing images on uncalibrated monitors can result in the color being seen inaccurately. I decide which images will appear in black & white, or sepia, or with cross-process actions. I do not limit what I shoot or provide to my clients. I give them everything, less rejects that don't live up to my standards.

**How do you handle album design?**
I have long designed my own albums, but I recently hired an album designer to help me better keep up with demand.

**Do you offer portrait packages?**
My packages currently include a set of proof prints only. Some packages also include a large single- or multi-image print for display at the cocktail party before the wedding reception.

**Are there any business particulars you'd like to share?**
When I decided to focus on wedding photography, I quickly determined that I wanted to compete on quality. I did not want to offer a cheap product that would be shown to potential clients. When I launched my business, I hit the ground running, with print and online ads, a full web site, several full wedding albums, and my best work to show.

I have seen people decide to shoot weddings before fully learning the techniques of their craft to ensure success. I think this is a shame, as trying to learn photographic and personal skills at a one-time-only event can have disastrous results.

I do not have a business plan, but I have goals that I exceed each year. My growth rate has been tremendous. I do not currently pay myself a salary but may look into incorporating it if my accountant determines that it would be worthwhile.

**What challenges do wedding photographers face?**
Rather than list challenges, I want to provide a few important suggestions that apply to any photographer who wants to be successful in this competitive business:

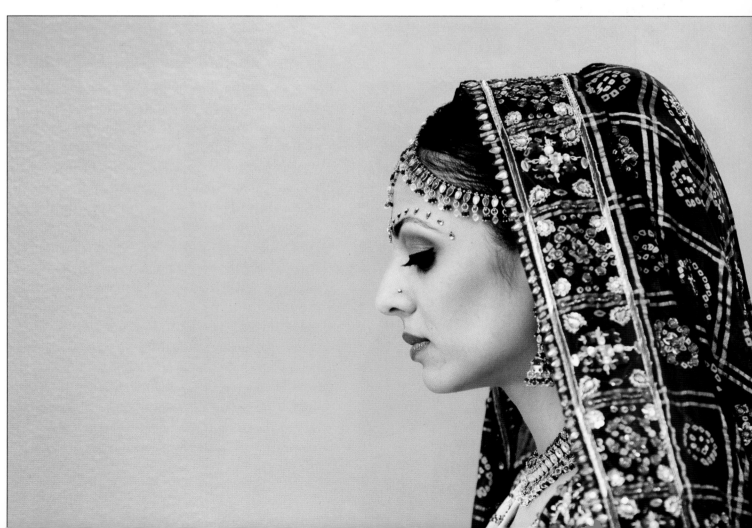

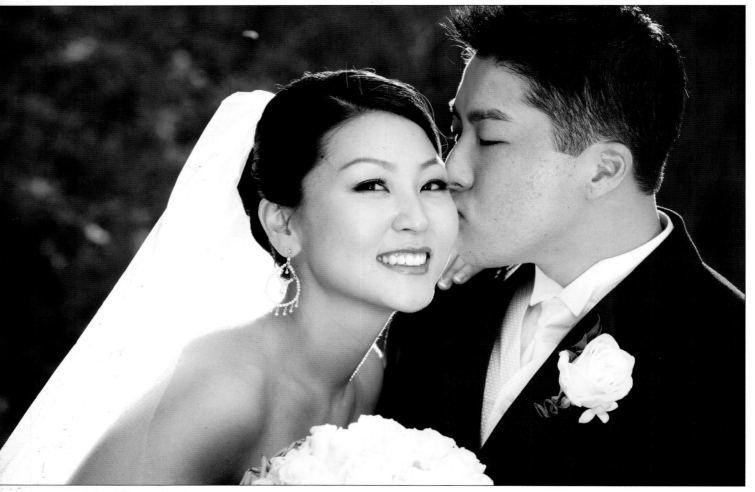

- Set aside a reasonable chunk of your income to pay for wedding albums when your clients request them. It can be a financial mistake to spend what comes in without realizing that twenty clients haven't returned for their (expensive) wedding albums. Photographers have gone out of business because they didn't set aside a financial buffer against payments due. It will also protect you if you are injured or ill.

- Treat your clients well and honor your commitments. Try to exceed their expectations in everything you do, and try to deal gracefully with complaints.

- Remember that the online galleries and albums you create will likely be circulated to hundreds of people. Wisely take care to ensure that your images, color, and albums look impressively professional.

- Honestly assess your capabilities, then benchmark yourself against the capabilities you know exist in your marketplace. If you can't be objective about your own work, ask a few talented colleagues to look

at your work and give you their honest thoughts. Find out where you need to improve, then work hard to fill the gaps. Identifying your strengths and weaknesses will help you artfully steer your business toward success.

- Keep innovating to ensure that your technological skills keep pace with professional standards.
- Understand that this is a business, not a hobby. Make decisions based on solid business principles. The hardest work comes after a wedding. If you're not able to manage that kind of workload pressure, hire someone to do it for you or outsource parts of your business.
- Keep abreast of current trends and client preferences. What looked great in 1985 does not appeal to the modern bride.
- Try to maintain perspective. Take the time to review what you are doing and what's ahead. That's what the good competition is doing.

George Weir is based in Hudson County, NJ, and in Lancaster County, PA, which allows him to serve clients from Pittsburgh to Philadelphia. On his web site he informs clients that "weddings are like tribal gatherings. Several tribes come together to celebrate the birth of a new tribe." He says that he wears no tie, kilt, or tux but always dresses smartly. George promises clients that "the images are there at each wedding. I just have to look and see."

### Describe your background.

My eldest brother, Andrew, patiently taught me how to look for images, and at age sixteen I knew that photog-raphy was the only thing I wanted to pursue. I admired pictures in *Vogue* and was stunned when viewing Donald McCullin's work. I was convinced I'd be photographing conflicts eventually, and helping end man's inhumanity to man.

In the library of our small town in the West Highlands of Scotland I read all the *Time-Life* photography series. At sixteen I had saved for a Russian Zenith SLR, but the shop owner offered me an old Exa 500 with a Zeiss Tessar lens plus a Weston meter. That camera served me well for years, and later I studied photography at Napier University in Edinburgh. In 1984, after immigrating to the

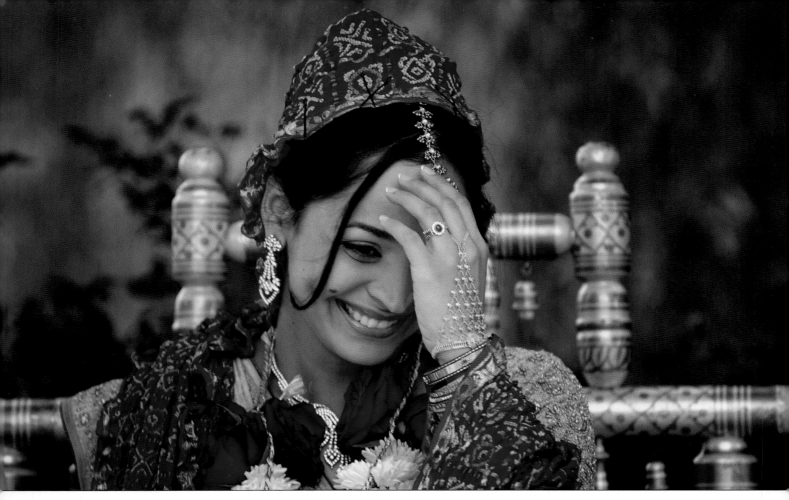

U.S., I worked as an ophthalmic photographer and learned a lot about how to get pictures in difficult circumstances when events could not be repeated.

### How is your career evolving?

In the mid 1990s I accepted a one-year contract in the Middle East to train photographers, design a custom digital imaging system, and head a department in a large eye hospital. Returning to the U.S. in 1998, I concentrated on wedding photography and began shooting for various regional studios in New Jersey and Pennsylvania. After one season I went on my own with a medium format camera that was too heavy and too slow. I switched to 35mm manual Nikons and two lenses, my favorites for years. Eventually I used the Leica M6 with four lenses, all f/1.4, f/2, or f/2.8.

### Who are your influences and mentors?

Roberto Matassa was an early and lasting influence. He was a freelance photographer living and working out of his ice cream parlor–cum–camera shop in a small Scottish town. He shot large format landscapes all over the globe that influenced how I saw the world. Other influences were August Sander, Paul Fusco, Arnold Newman, David Bailey, Barry Lattegan, Terance Donovan, Eve Arnold, Norman Parkinson, and Ryszard Horowitz.

A more recent influence is Mark Wygent, an "open" class bagpipe player who was my son's solo tutor for several years. He talked about achieving a level of competency, knowledge, and skill wherein one would "own the music" so no one and nothing could detract from the performance.

That described for me the feeling of a "thump" in my gut as I capture certain images that are beyond the ordinary. I strive to capture what others cannot do or see.

### Do you shoot locally or at more distant locations?

Most of my weddings are on location, meaning more than seventy-five miles from my office. I tend to seek weddings two hundred miles away or less. Travel costs are factored into my base fees. My current booking forms list specific rates for certain metropolitan areas. When clients contact me for weddings more than two hundred miles away, I outline the travel fees involved.

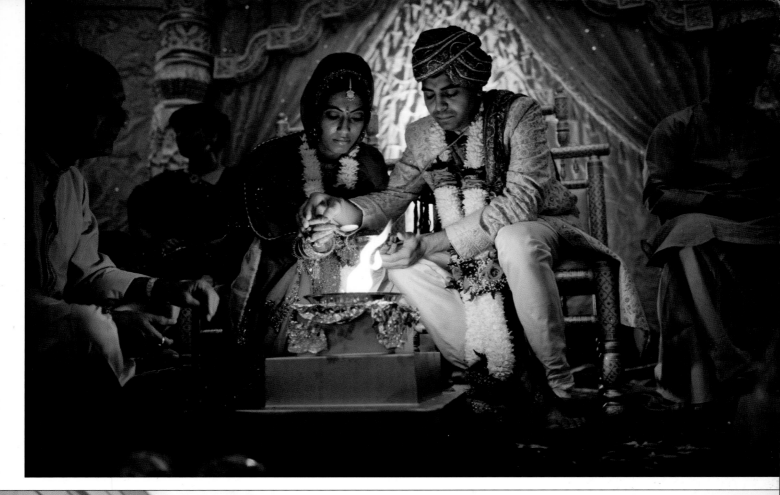
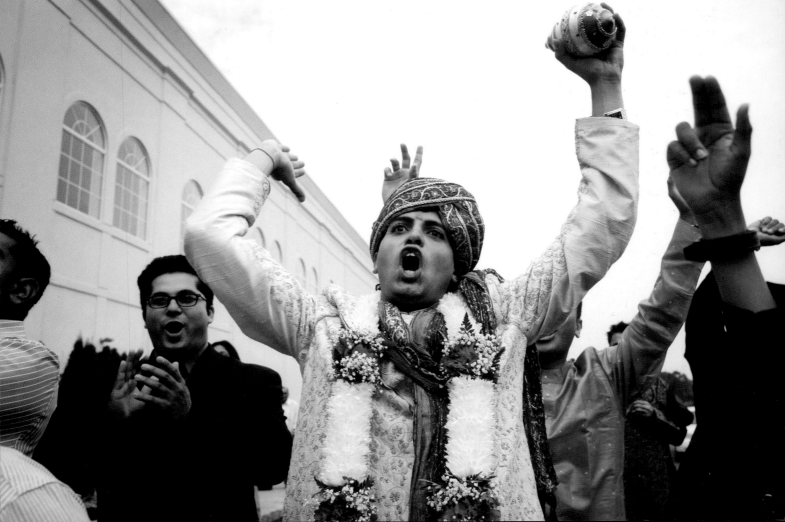

I don't function well in a studio for some reason, and I don't have one. My office is at home, and I like the challenge of making do on location.

**Describe your approach to scheduling sessions.**
Weddings are scheduled from two or three months up to eighteen months before the event. I use Photo One Soft-

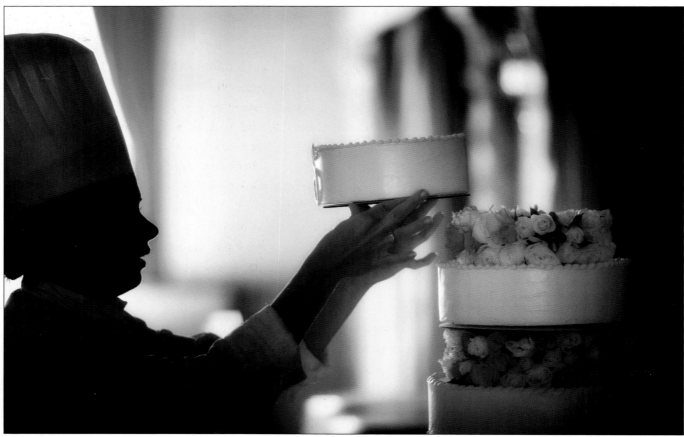

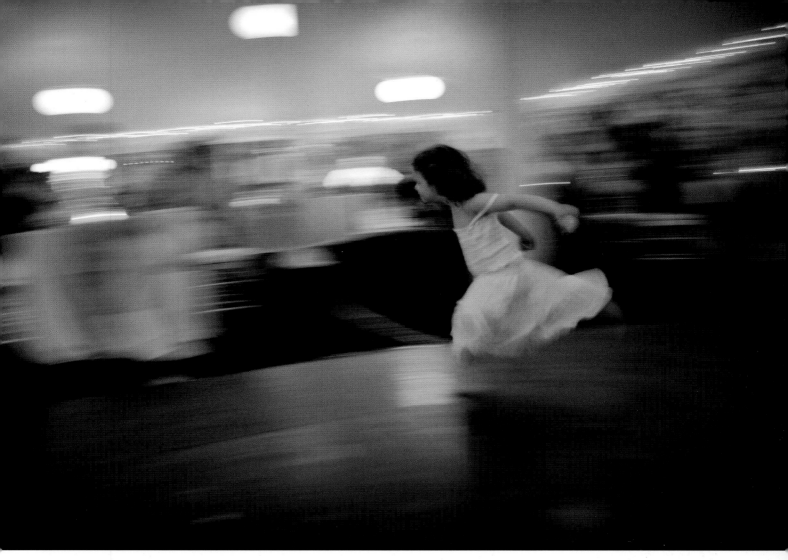

ware to keep track of client information from contact to completion of the wedding job. Photo One Software has some powerful functions and capabilities to help keep my work on schedule and allows me to maintain records. Information is backed up on a daily basis.

I shoot a maximum of two weddings on Fridays, Saturdays, and Sundays. Thursday is my day off; Monday through Wednesday I work on production and marketing. If possible when I book a wedding, for my convenience, I consider its location and distance from another wedding already booked that weekend.

### How do you handle retainers and fees?

A five-page PDF is e-mailed to 90 percent of my prospective clients. The PDF includes coverage descriptions, fees, terms, conditions, and a booking form. I will hold a wedding date for three business days pending the arrival of the client's agreement and retainer. Protect yourself against individuals who say you have been selected and the agreement is in the mail. You may discover they have chosen someone else.

My 50 percent retainer guarantees the date, is nonrefundable, and helps protect my business in case of cancellation. The retainer is required to hold any date, and payment by check is specified in the agreement. For every wedding I book there has been at least one other potential client wanting that date, and I assume another photographer has been hired.

I offer three basic options to clients, and the fees vary depending upon which of the following options they select:

- My coverage without an album option includes a set of matted prints in a portfolio box. This is not available on premium dates. Files are available for purchase one year after the wedding.
- Coverage with a standard size album is my default package. This allows for up to eight hours' coverage.

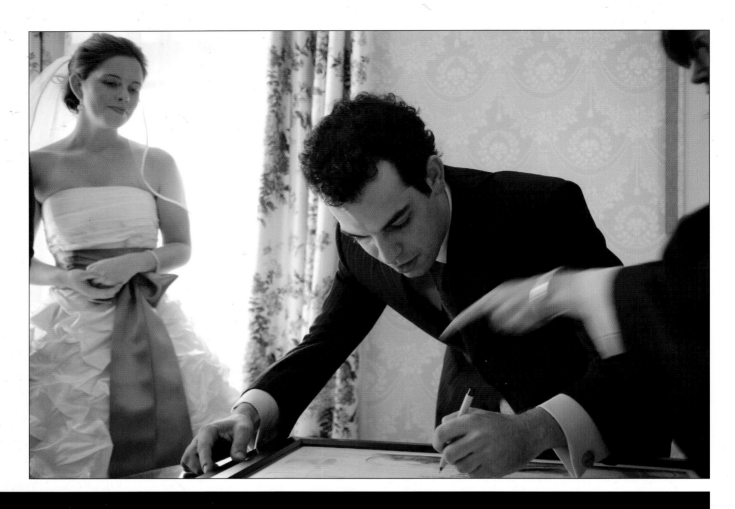

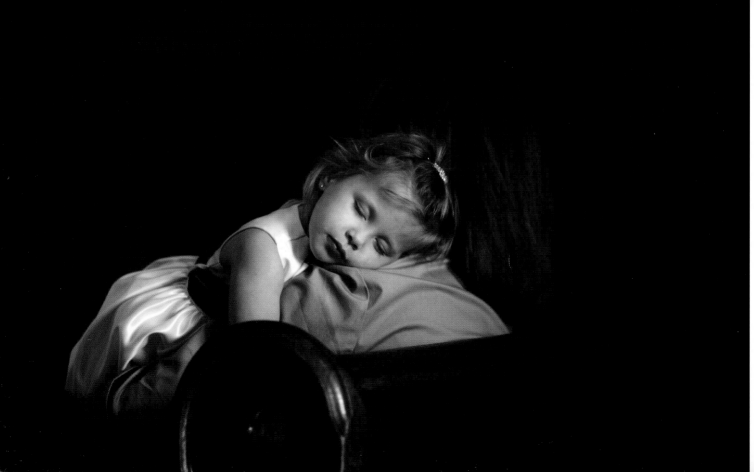

There are no restrictions on availability of dates. Files are available for purchase one year after the wedding.

• Coverage includes extended hours and a larger album with more images. Files are delivered in less time.

Every client receives either custom matted prints in a presentation box or in an album. All albums have fifty pages and a maximum number of images, which is determined by the physical size of the book. Coverage may be for six, eight, or ten hours.

Parent albums are usually smaller "clones" or reproductions of the main album, though custom-designed parent albums are available. Fees include a certain amount of travel, and I offer preset fees for certain metropolitan areas to cover parking, tolls, etc. Overnight accommodation is charged for any location more than three hours' drive from either of my office zip codes.

I never allow clients to make my reservations for rooms or flights as I may need to arrange for shooting schedules prior to or after an event. All packages may be modified for individual clients. In the last several years I have required that clients make a minimum donation to one of two charities. In return I offer a 50 percent re-

duction in my fee (e.g., a donation of $250 reduces my total fee by $500).

### What terms are covered in your contract?

I keep them short, simple, and as unambiguous as possible. They are reviewed by my attorney. I allow changes or alterations to my contracts to accommodate clients rather than rewrite and print another agreement. I go over the wording with the client, and they handwrite changes, sign and date the changes, and return the original to me. I am protected with evidence that the client's signature is on the contract in various places.

My contract details:

• What is being provided and at what price
• Terms of payment
• Retainer

- Explanation of nonrefundable retainer
- Only one client signature so you are not caught in the middle of a couple who have separated unhappily.

### Do you have an assistant?

I prefer to shoot solo. My wife gives me invaluable strategic and tactical advice, which I would be lost without.

### How do clients find you?

Sixty to seventy percent of my clients are referred by current and past clients. The balance comes from Internet searches or referrals from other photographers. Prospective clients are looking for assurance that I will be able to photograph their wedding on a suitable date and location. They want to know my fees and album potentials.

I keep in touch with out-of-town clients and arrange meetings when I'll next be in metropolitan areas near them. I combine several meetings in a city or area to make best use of my time in quality locations. I have no problem shipping a sample album to clients in other parts of the country.

### Do you visit the location before the event?

I do not preview locations in the wedding vicinity. I'd be willing to if the client was willing to pay for my time. I'm pretty good at making the best of available portrait locations that I have discussed with the client. I make the decisions, but I am quite willing to shoot wherever they choose if it's practical.

### How do you handle travel arrangements?

A travel agent is indispensable if I am flying. When driving I anticipate driving distances and make my own hotel reservations. I carry a "shoot binder" filled with wedding details and the contract. Locations are pre-loaded into my GPS, and there are detailed area maps in the trunk.

## What equipment do you favor?

I have a minimum of five Canon cameras, about eight lenses including a fast f/1.4 50mm, and a spot meter. I carry enough CF cards to shoot three weddings without reusing any. I also use three or four Canon 580 strobes with wired IR and radio remotes, a light stand, a tripod, and gaffer's tape. Generally, I'm happy with two bodies plus a 35mm and 85mm lens.

I've always been a believer in fast lenses and I use as little flash as possible. That said, I keep at least one strobe on my belt, and I may place one on a stand and trigger it optically or via Pocket Wizards. I use a strobe on camera as needed.

## Describe your photo timeline.

Before the wedding day I remind clients that I will do whatever is possible to make it a memorable occasion. We go over my usual working approach and I answer their questions. Based on the discussion I suggest a timeline for pictures. If they have additions or changes, we work on them until we are all comfortable.

Immediate family has been alerted about when we will be shooting portraits. On the day of the wedding I carry short simple notes about the timeline and other details. I work with all the other professionals to achieve harmony with DJs, videographers, maitre-d's, etc. I do my very best to be flexible and still retain a degree of control.

### Do wedding photographers have recognizable styles?

Some photographers do develop their own recognizable styles. My images have to please me first. If they do that, then they usually please my clients. In some images style cannot be apparent. An example is a large group shot of

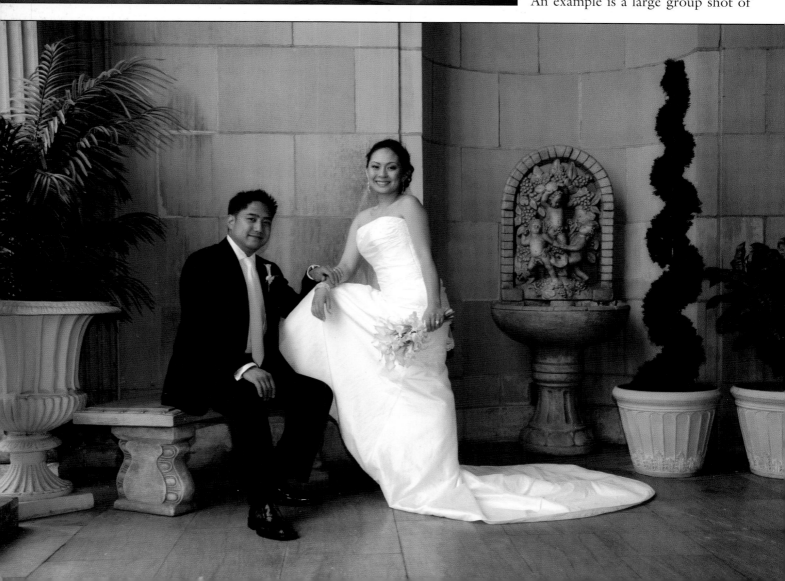

two families in a moderately dark church. The resultant photograph may not be a Weir-style image, but I get a large number of shots in a short time, treating the families with respect. And we had fun. How many variations can one expect of a cake cutting? That's where style can really come through.

### Do you have any tips for handling the unexpected?

I shot a wedding in Western Maryland, about three hundred miles from my home. The night before, I drove there and checked into a hotel about ten minutes from the ceremony location. I was due to start shooting at 11:00AM and arrived early, pumped up by great light. By 11:00AM no one had arrived, and it was pouring rain. I checked a calendar and the contract, and I was in the right place at the right time. In splashing rain I phoned the place the bride was to be and she told me she was running late. When I told her where I was she asked if I had received her letter. The couple had moved the ceremony to a more scenic spot ten minutes away. I raced to the new location, in a very dark historic barn where October overcoats and hats were worn for the dancing. However, it really was a super wedding, and I was pleased with the album I designed.

### How do you handle your workflow?

Prior to a wedding, CF cards are numbered, front and back. Used cards are placed in a card wallet that stays on my belt until I arrive home. Using PhotoMechanic, all images from the cards are moved into a specific client folder. Images are sorted by camera serial number. I also photograph the face of a small watch as the first image in each camera, indicating sequence of use. All images in the folder are sorted by capture time and renamed with a sequential number.

During the edit I tag only the good images and indicate each for black & white or color printing. This edit results in six hundred to eight hundred images. I leave the images for a few days, then go through them again, resulting in about five hundred images. These are renamed and backed up on two hard drives and a DVD. Image galleries are made for online viewing and are uploaded on the second Wednesday after each wedding.

### How do you present your clients' images?

I show clients my images online. Prior to a wedding I discuss client preferences for color or black & white. Though I capture everything in color, I can convert to black & white later. All images not up to standard are

My most important decision was to shoot weddings the way I wanted to without concern for what others did.

My business plan is reviewed once or twice a year. Strategies and tactics are reviewed regularly. I pay myself a salary. I believe that failure is commonly due to not understanding basic costs and not charging realistic fees.

### Is there a philosophy that guides your wedding photography?

I feel that weddings are tribal gatherings. Families gather to witness and share in the start of a new tribe, and my job is to tell their story. I am usually able to stay detached and keep my enthusiasm high. I have a need to capture images that tell stories, and I'm quite good at it.

I actually took a vacation in 2007, my first real one in many years. During seven days my wife and I did not discuss any business, and I rediscovered the pleasure of shooting for myself. I came back with a strong portfolio of non-wedding images and felt more energized. We want to do a "regrouping" trip each year along with giving myself a project or two.

### What challenges do wedding photographers face?

- More clients are seeking ownership of digital images. If you concede, attach a dollar value to them.
- The gap between amateurs and professionals has significantly narrowed. Digital technology and the Internet have enabled many people to achieve a level of competence unimaginable a few years ago. The number of people with cameras who can do a reasonable wedding job has grown. Overall wedding photography standards have raised, but sadly, many individuals offer their services at unrealistically low rates.
- Professionals are regularly challenged to demonstrate the value of their services and images.

trashed. I include some alternatives for some of my formal portraits.

### What do your packages include?

My smallest package includes a set of enlargements, 8x10 or 11x14 inches, in custom-made double mats in a folio box. Reprints are available online, and the most common sizes are 4x6 and 5x7 inches.

### Describe your approach to album design.

Clients may select album images or leave it to me. I add minimal Photoshop effects and send them to an album company for layouts. My current designer understands the look I want, and few design changes are needed. Most clients view album designs online. Prints are made on a Durst Lambda printer. This is more pricey than the norm, but the quality is stunning.

### How do you promote your business?

Most promotion is through word of mouth. I also maintain my web site and target specific geographic locations. I constantly review where visitors come from, what they look at, and where they exit.

# 4. LIANA LEHMAN

*www.lianalehman.com*

Liana Lehman wanted to do wedding photography long before she eased into it. She works from a fine office in her Madison, GA, home and shoots only on location. In 2006, Liana was the featured photographer for NBC's regional *Going to the Chapel* program. Potential clients can view the live interview playbacks on her TV web site (www.liana.tv). While working on this chapter, she photographed a wedding in Greece, and stayed for a vacation.

### Describe your background.

As a freshman in college I shot pictures at parties and enjoyed perks as the photo editor for Florida State University's independent biweekly newspaper. In a short time I had inquiries for portraits as well as commercial and fashion work. At that point I had no formal training. In 2000, I made the decision to enroll in Lively Technical College's commercial photography technology program.

We'd studied everything from the ten shades of gray and rolling our own film to printing and presenting medium-format commercial work in color.

### How is your career evolving?

I've been in business since 1999, but for five years I refused to shoot weddings. I tried other types of photography and assisted a wedding planner. In 2004, I moved to Atlanta from North Florida where I was burned out trying to make a living. Just before the move, a bride-to-be twisted my arm to shoot her wedding. She asked me to creatively incorporate my fashion and photojournalism background and do what I wanted. She also offered a nice fee, so I took the job—and really enjoyed it!

I decided if people paid me enough, I would shoot some weddings, so I retained my web site. A few weddings later I became part of the exclusive Wedding Photojournalist Association (WPJA), and inquiries poured in from referrals and my web site. With the support and encouragement of many peers, I left a well-paying position managing advertising and marketing communications for a large accounting firm. My love for photography was reignited because I was able to shoot in a style I preferred. Sharing and learning with others has been key

to going back into full-time professional photography. I now specialize in destination wedding photography and also shoot a handful of other events and sessions requested by referrals and current clients.

### Who are your influences and mentors?

My inspirations come from my diverse background. For a fresh perspective I look at what fashion and commercial artists are doing. Traveling and experiencing other cultures is also inspirational. I see myself as part of the "new school" of photographers because of my style. I try to keep up with what other photographers are doing via blogs, publications, online forums, and seminars. I budget for three or four educational opportunities each year.

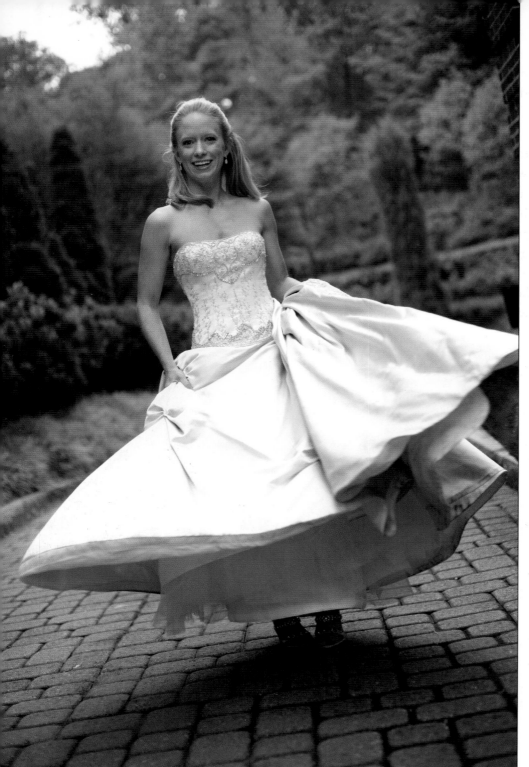

We generally book up to a year in advance, and closer to the wedding on less popular dates. We schedule four or five weddings a month in the busy season and two or three in less busy months. I do quite a bit of teaching and speaking at industry events and seminars in winter months.

### How do you handle retainers and fees?

A wedding date can be reserved only after a signed photography agreement is in our hands, plus a retainer which is 30 percent of the package price. Retainer funds are kept in a special account to cover some costs and sales tax. The client may pay in full or in up to three installments—one hundred and twenty, ninety, and sixty days before the wedding.

Our pricing changed when I applied the principles of managerial accounting to the business. Now we have numbers to measure our success against using PPA's 2005 Studio Benchmark Survey Report. For over a year an accountant analyzed figures submitted by one hundred and sixty wedding and portrait studios. The findings were shocking. The take-home pay of most wedding photographers was less than $33,000 per year, and less for others.

I use separate price lists for local, regional, national, Caribbean, and European destination weddings. My travel expenses are included. I serve a mid- to higher-end market, but similar packages are shot by associate wedding photographers who work for us as independent contractors. This allows us to deliver a similar great experience if I am booked elsewhere or clients have budget restrictions. Our pricing ensures that we earn a certain amount out of every dollar after our overhead, appropriate salaries, and all busi-

### Describe your approach to scheduling sessions.

Most scheduling is done through e-mail and then by phone. I handle client communications (my assistant does when I am away), and my design team handles albums, slide shows, and portraits after the wedding. A majority of weddings are on Saturdays or Sundays. We've done a number of two-wedding weekends, including one for NBC.

ness expenses are covered. We arrange packages for associates in a market that is often saturated.

## What is covered in your contract?

Our contract spells out all the details agreed upon by our studio and the client. Included are the wedding date and time, inclusions in the package, and arrangements to purchase the digital image disc. Also in the agreement are model releases, terms and conditions about photo usage, proofs, frames, album design plus changes, payment, and cancellation policies. The contract also covers client responsibility (please feed the photographers!), limit of our liability, federal copyright coverage, original proof information, and exclusivity and authority.

Should an issue occur, a contract protects both clients and photographer. We've found that clients expect to sign an agreement.

## Do you work in the studio?

My photo shoots are conducted on-location, so I have no need for a studio. I meet clients in my home office occasionally. My assistant works part-time while I'm away, and with the help of communication services I stay mobile.

I shoot a mix of local, national, regional and foreign weddings. More couples are choosing destination weddings, often in special locations. For almost every wedding I hire other photographers to do second shooting and assisting. Some may have their own business.

## How do clients find you?

Ninety percent book me online after we trade e-mails and

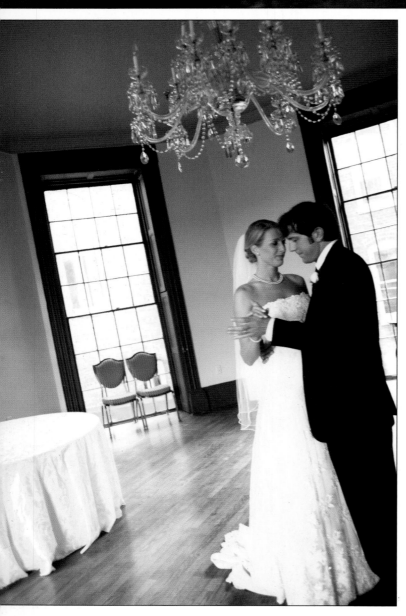

sometimes after a phone conversation. If clients decide to meet with me, it's generally because they are shopping around or want to discuss weddings dates and sign a photography agreement.

### Do you have any tips for handling the unexpected?

I love it when guests or the bride and groom want to see what I've been shooting. It helps give them confidence that they look fantastic and excites me about taking more pictures! We do on-site slide shows at receptions when possible.

### Do you photograph smaller weddings?

I'm pretty firm on prices but like to be flexible with custom packages for clients who have smaller, unique weddings and special situations. These jobs may come up at the last minute and when available, I might do the photography or have an associate do it. For instance, in my busiest month of 2007 I got a Monday call about photographing a justice of the peace ceremony for an hour on Tuesday. The couple had been waiting ten years to get married, and I happened to be available. It was a nice break from regular weddings.

### How do you handle your travel arrangements for location shoots?

For destination weddings I book my own travel, and I use the same airline and hotel chain as often as possible. You can save a lot by accumulating sky miles and points for hotel or credit card rewards. I book directly through airline or hotel web sites for the best rates.

### Do you visit the location prior to the event?

We usually arrive at a destination a day or two ahead of time and often stay on site so it's easy to preview the surroundings. My clients often tell us about great photographic spots unique to their location where they would like us to shoot. I feel I can adapt to any location and work with what is available. Some of my favorite images were taken behind a loading dock garage at the Rock and

Roll Hall of Fame in Cleveland. I enjoy the challenge of finding unique backgrounds.

### Describe your photo timeline.

Because of my photojournalistic style, we usually "go with the flow" regarding a wedding timeline. We stay in phone contact with the client and/or wedding planner to solidify arrival and departure times, and discuss a run-through of the day's activities. Some clients e-mail us a timeline with special requests.

Many clients arrange to meet before the wedding for bride and groom portraits to eliminate rushing later. The old not-always-wise tradition about bride and groom not seeing each other before the ceremony was devised in the days of arranged marriages. When clients realize this, they usually don't mind shooting together before the wedding, which reduces stress. Plus, they get gorgeous pictures in those moments, and more images.

From the reception on, we resume the "fly-on-the-wall" position to capture candid moments including the first dance, toasting, bouquet and garter toss, dancing, other fun happenings, and the farewell.

### Do wedding photographers have recognizable styles?

In an ultra-saturated wedding photography market I believe it's crucial to develop your own recognizable style. Clients are attracted to it and hire you because of it. Plus, their expectations are set ahead of time, and you're sure to have happier clients!

### What type of tools do you rely on to get the images you're looking for?

I shoot with two Canon 5Ds and absolutely love having a full-frame sensor. My favorite fixed focal length Canon lenses are the 100mm f/2.8 macro, 50mm f/1.2, 28mm f/1.8, and the 85mm f/1.8. The 15mm fisheye is fun at

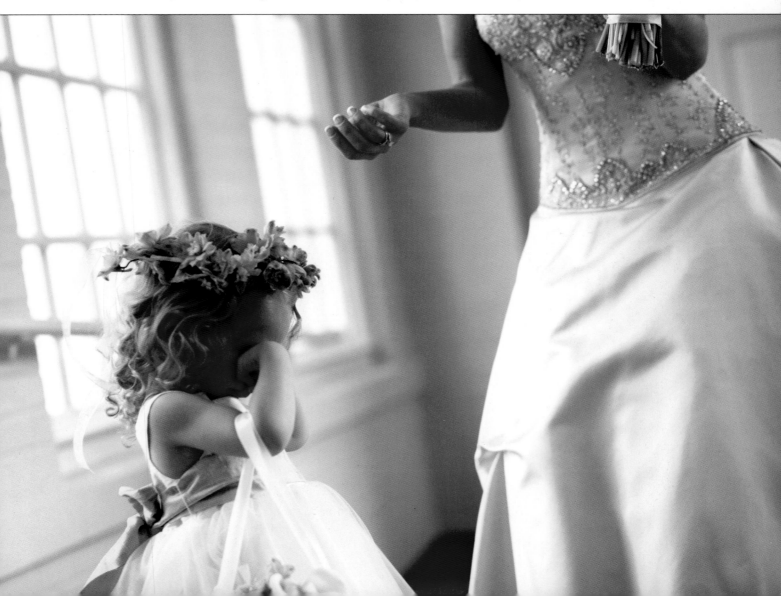

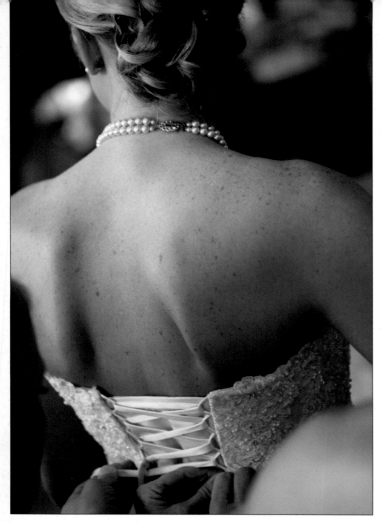

destinations occasionally. For weddings closer to home I also use the 70–200mm f/2.8 USM (ultrasonic motor) and the 24–70mm f/2.8 USM.

My cameras, lenses, and two flash units that will trigger each other, plus my clothes fit nicely into a carry-on bag so I don't have to check luggage. I also pack a few folding cotton tote bags, and at the wedding all my equipment fits into them.

Though I own a portable studio with strobes, I've never used it at a wedding. We use as much natural light as possible and open blinds or shoot at a high ISO in darker environments. This approach contributes to our style. When we must use flash, it's off the camera, and if it's on the camera, it's bounced from a wall or ceiling. At a reception we set up a number of off-camera flashes with Pocket Wizard wireless remotes triggered when needed. Sometimes I use flash on camera bounced for fill, and off-camera flash as the main light.

### How do you handle your workflow?

Our workflow system is refined to allow us to show clients products and proofs ASAP. We shoot all manual and use custom functions to shoot black & white in-

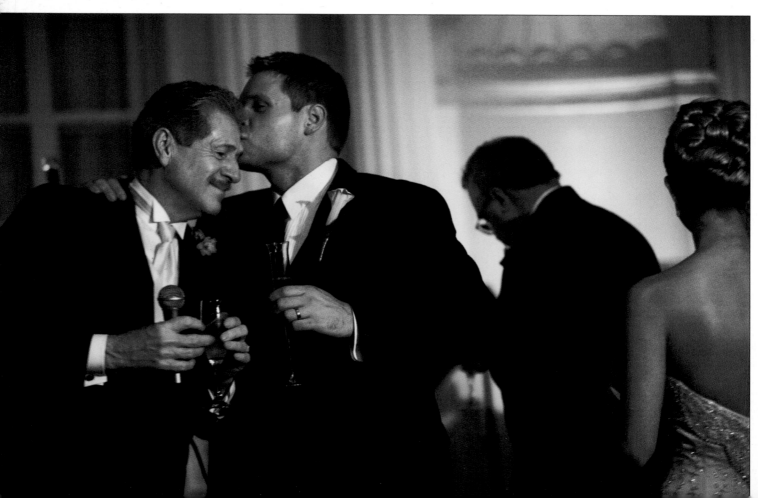

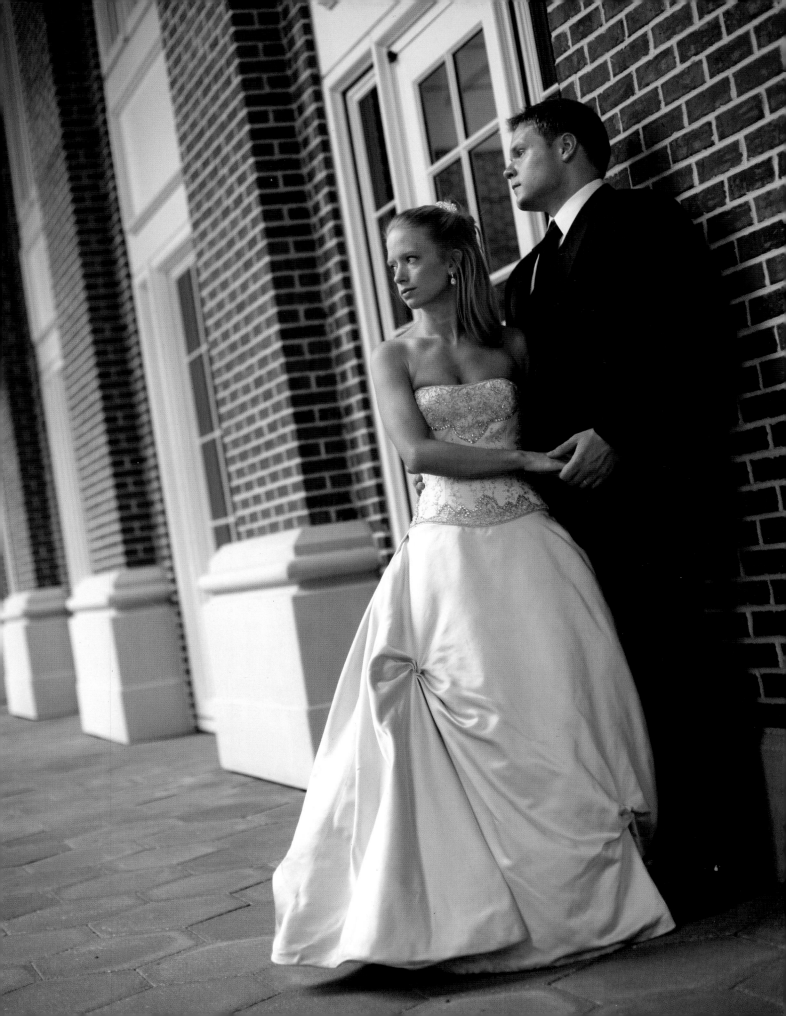

camera to reduce conversion times later. The less time spent behind the computer, the better.

Workflow starts when a client folder is set up with sub-folders ready to download images immediately. At the reception, when people are eating dinner, we download the main shooter's images onto a laptop using Adobe Lightroom which automatically backs them up to our external hard drive. Then we pick out fifty to one hundred images using Lightroom's Quick Collection function. A slide show is soon ready to show on the laptop, which is placed on a gift or guest book table along with our business cards so guests will know where to view pictures online. The immediate slide show provides instant marketing and always creates great responses.

If we have a second laptop with us we'll continue to download image files that are backed up, and the editing process begins using Adobe Lightroom. We select an average of seven to nine hundred images from the two to four thousand captured images. The "keepers" are exported to multiple sets of DVDs, and one set is overnighted to my lab for upload and categorizing. The lab also archives copies in case of an emergency. The keeper selection is narrowed down to a few hundred that my design team uses to build a gorgeous album. The client uses a draft design as a starting point for their final album.

Finally, we select one hundred or so images for an online slide show that can be e-mailed to friends and family. We include both color and black & white. Clients trust us and appreciate being able to preview images as we see them. Within a week of the wedding we usually post an entry on the blog with our favorite pictures. Links are posted to the album design and slide show, and we aim to have everything ready for viewing when the couple returns from their honeymoon.

## What do your packages include?

A print and album credit is included with our most popular wedding packages to allow clients flexibility to decide. The majority order a custom flush-mount or coffee-table album. Many order two-volume sets plus duplicate albums for parents and travel. My in-house design team makes choices to best show the wedding day story, including details, portraits, key moments, and sequences. Clients are grateful for our help in displaying their photographs, which helps make their investment worthwhile.

## How do you promote your business?

Most of my business is generated via web site and word of mouth. Brides connect with each other via wedding forums and web sites, and their word-of-mouth recommendations flow smoothly. Much of our marketing is in slide shows on-site and online on the blog. The news blog (www.lianasbananas.com) has been very useful for bringing in new business. Many potential clients tell me that our blog connection was key to their booking me.

Our three-part web site won the Professional Photographers of America (PPA) 2006 AN-NE Best Web Site Award.

## Is there any business advice you'd like to share?

A decision I made early in my career was to "learn the rules, then break them." I believe having a strong focus and vision for your business is crucial. We aim to help clients. Their friends and family achieve the impossible and experience the beauty that is about them always.

Keeping a business plan up to date is important. To make wise business decisions you must be aware of how much money is coming in and going out, and how many jobs you need to book for the necessary monthly income. It's also important to set money aside for taxes, cost of sales, and savings.

I know from my work, plus teaching and consulting with others in the industry, that money is the main reason photographers fail. They don't understanding managing business finances. I make "planning dates" with

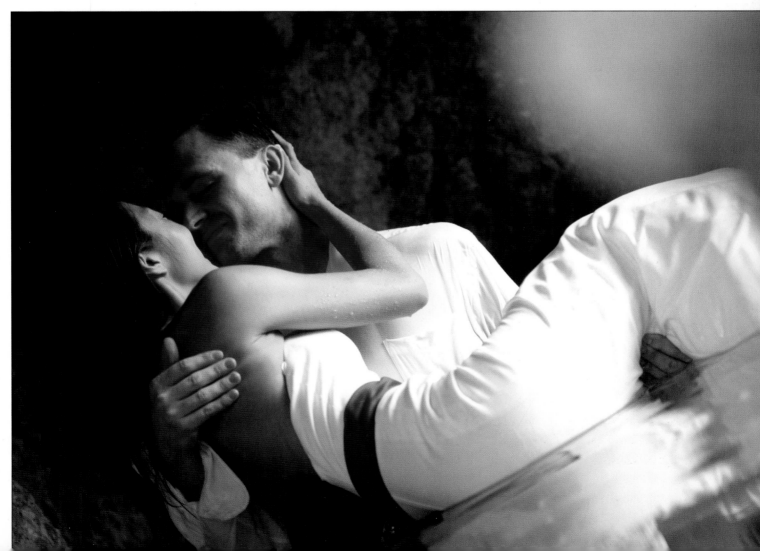

myself and my team at least once a quarter to review progress, and we have a running tally of what our progress is by the week as well.

### Is there a philosophy that guides your wedding photography?

I am able to capture the emotion and stories of a wedding day because of my experience in previous photographic disciplines. I believe that most people have beauty to share and a story to tell through photographs. Thus, it is very fulfilling to create images that others will love. The diversity of my clients and the venues where I shoot keep me authentic, original, and inspired. I'm always trying something new and looking forward to the next wedding.

### What challenges do wedding photographers face?

I posed this question to a few hundred photographers I spoke to at a national convention, and here are their responses. I discuss these challenges regularly when I'm teaching.

- Not having enough resources (money and time) to grow your business
- Difficulty managing time
- Seasonal cash flow issues
- Spending too much time on the computer
- Knowing how to market wisely
- Keeping up with technology
- Finding time for more education
- Balancing work and life
- Dealing with negative people

Cliff has been a professional shooter for twenty-six years, and he evaluates himself quite frankly. He has a voluminous studio in Haddonfield, NJ, in a remodeled church. In time he plans to create a residence in the church's lower section. Cliff's extensive big city newspaper background prepared him to capture momentary incidents and expressions at weddings. He has made many contacts with other vendors such as hotels and florists that recommend him. In lieu of a business plan Cliff says he has guile and people skills.

### Describe your background.

At age seven while on vacation I watched my family taking pictures and was enthralled. I bugged my parents for a $1 camera which didn't work, but the idea was so cool. I later got a suitable camera. I never studied photography, but in high school and college I enjoyed shooting. When I was nineteen I answered an ad by "an award-winning newspaper" seeking a photographer and was hired to do assignments on weekends for six weekly papers at a

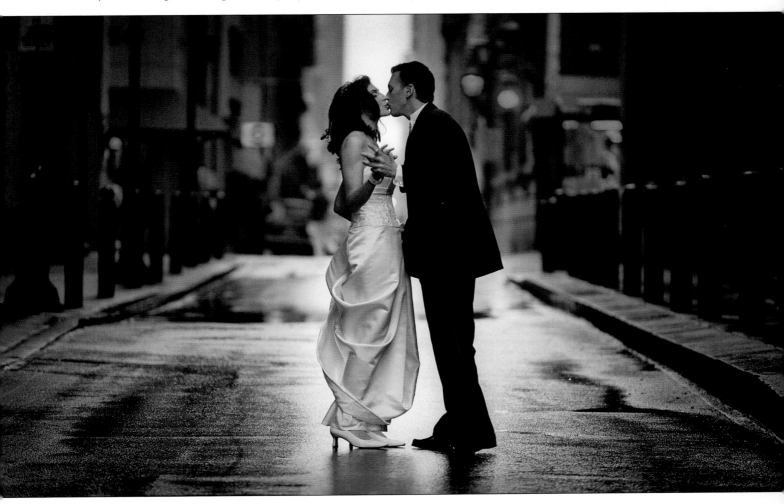

princely $75 a week. I also processed and printed all the garbage their reporters shot, because the paper couldn't afford a regular photographer.

After two years as a mediocre newspaper shooter, in 1984 a friend told me the *Philadelphia Inquirer* needed a photographer to shoot for weekly suburb inserts, and I was hired. At first I photographed incredibly mundane people who did incredibly mundane things. I shot six environmental portraits a week, in about ten minutes each, after finding the best light, backgrounds, and compositions. I needed to make subjects seem interesting, and I still use this skill at every wedding.

Shooting about six thousand assignments in fifteen years, I had a large dose of photojournalism experience, from spelunking to presidential campaigns. One early *Inquirer* assignment was to cover a meeting of breast-feeding mothers. At twenty-two, I was so green I was more uncomfortable than the bare-breasted mothers!

### How is your career evolving?

In about eleven years I've covered an estimated six hundred weddings. My first one was for a corporate client's daughter who wanted me to capture it like a news story—unobtrusive, edgy, and stylized. Since then I've evolved from a hardcore photojournalist to a softer, more sensitive wedding style. News-type photography is detached, and maintaining distance during a wedding made me feel I was missing opportunities to make flattering images of my brides. Once I realized that a wedding was an intimate occasion to make beautiful photos, I became a more insightful storyteller.

At weddings I've learned useful types of flexibility. I used to be afraid to shoot in noonday sun during June or July, but today images made with strong overhead light have become my signature style. My love for fashion-type photographs has also been integrated into wedding work.

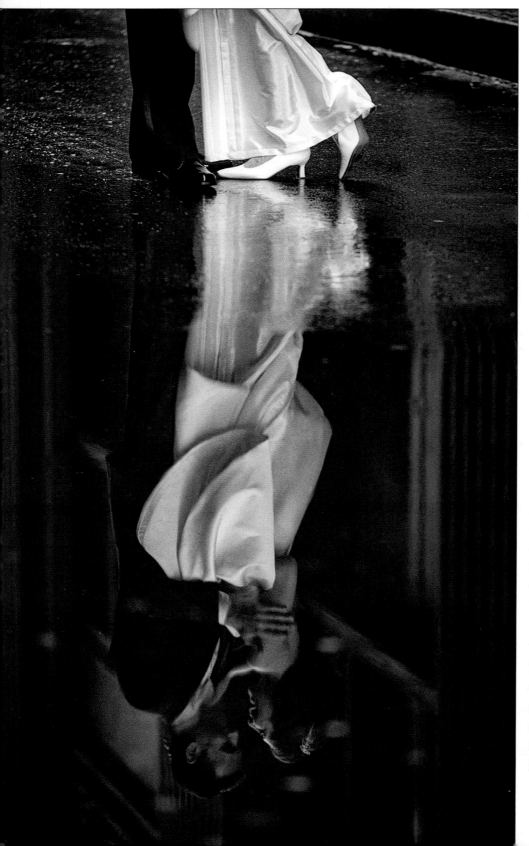

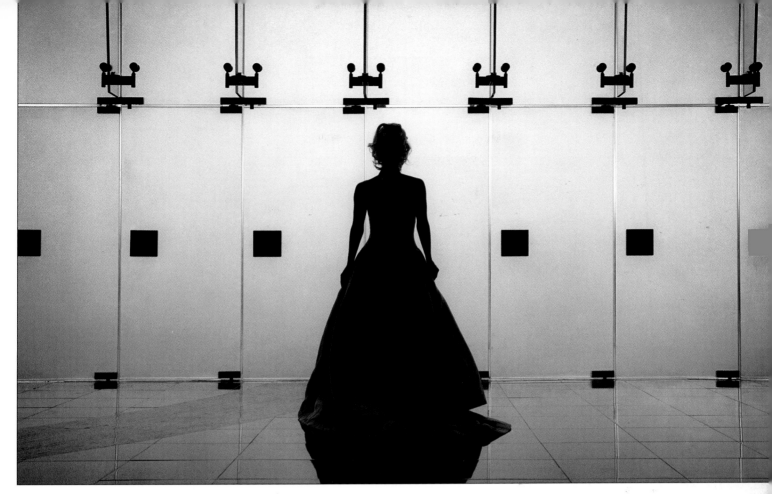

Perhaps the most helpful aspect of my evolution was bringing a more feminine touch to my images. Men may be at a disadvantage until they gain the bride's trust in order to capture the essence of who she is as well as what she looks like. Testosterone isn't the answer. For this reason I always work with female assistants. I feel I have a right to call my style "photojournalistic," but I'd rather tell clients I give them "an artistic interpretation with the best traditional aspects of wedding coverage." I also include intimate portraiture of the wedding day. By intimate, I mean revealing special things about the couple.

### Who are your influences and mentors?

An early influence was my *Inquirer* editor, Brian Grigsby. He taught me (a) to interpret the relationship between subjects within a frame, (b) that images can speak, and (c) that juxtaposition can be magical in an image. Other influences were Sarah Leen, Burt Fox, Tom Gralish, Eric Mencher, April Saul, and Jerry Lodriguss. They taught me about keeping an open mind and eliminating preconceived notions.

I was lucky to work with multiple Pulitzer Prize winning photographers. I admired Larry Price's simple yet powerful compositions. However, I never learned wedding photography from anyone. My inspiration is gained via films, magazines, and other art forms. On a rare occasion, I'll look at other photographers' work, but I need to envision images with my own mind's eye.

### Describe your studio and office.

I bought an old 5,000-square-foot church in the beautiful town of Haddonfield, NJ, in 2006, and I moved in after eight months of extensive renovation. An efficient workflow system is in place, and I couldn't be happier. There are two zones of rails with five Pro Foto Compact 600 strobes, and there's a 30x14-foot brick wall in the back of the studio with lots of versatile space. For natural northwest light I added a 16x14-foot bay of windows, despite the fact that I prefer location shooting.

My new studio is seldom used, except in winter, but it looks cool and provides an excellent client experience when they see a gallery of my work all around the main floor. Client meetings are held in a very comfortable furnished area with a 92-inch high-definition projection system and Boston Acoustic surround sound. My studio manager handles operations.

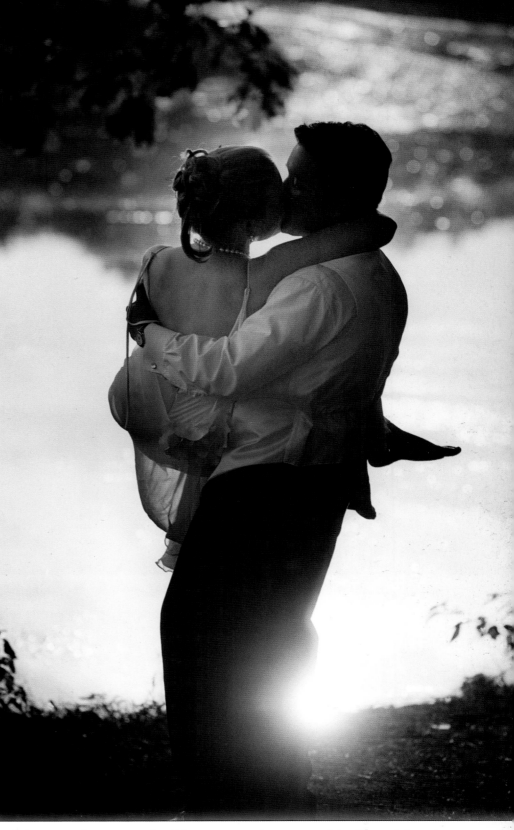

### Do you shoot locally or at more distant locations?

I shoot weddings mostly in my Philadelphia and New Jersey markets. Only recently I began to enter the destination market. It's not really my preference, but I enjoy it on occasion. I can earn more money doing two local weddings on a given weekend than if I were to fly somewhere.

### Do you visit the location prior to the event?

I never scout a location. As a professional I feel I am able to sum up a facility or location instantly, and ideas will come to me when I evaluate the light.

When asked to visit a location, my response is, "I understand your desire for me to preview the venue, but as an experienced professional, I can review the area within minutes. In addition, I like the venue to be fresh in my mind to develop creative ideas. Besides, the light on your wedding day may be very different than the day I visit. Trust me that I really don't need to see your venue first."

### How do clients find you?

Most couples hire me through word-of-mouth referrals, often from clients, which is the best way to get a booking. I also have first-rate relationships with hotels and restaurants in my market. I refer them, and they refer me. I've positioned myself as a center of influence, to help others with their businesses. In turn, they take care of me. It's an excellent way to build a business.

Wedding budgets have escalated over the past few years. You learn to look hesitating clients in the eye and tell them you're worth it, and they have more respect for you. Confidence goes a long way with clients. My attitude indicates I would do a great job for them. They get the message, and they realize that I am honored to be their photographer.

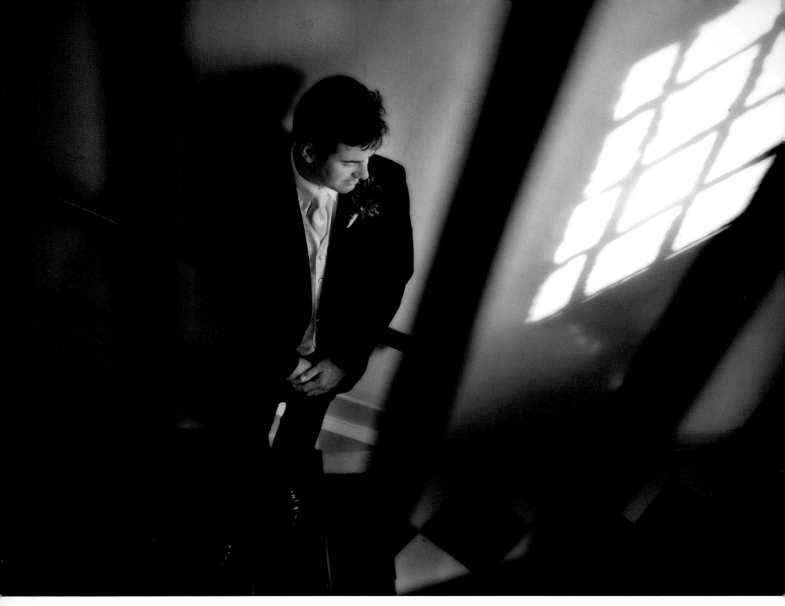

### Do you have any tips for handling the unexpected?

A few years ago I had a true bridezilla, but her mom was even worse. Starved for attention, the mom pretended to have a heart attack the evening before the wedding. Next day, five minutes before the bride was to walk down the aisle, Mom was wheeled down the aisle by her husband. The bride had to trail behind, and Mom stole the attention, as she planned. I tried to just go about my business as if everything were normal.

Another time, a couple booked me eighteen months prior to the event. I later learned from the florist that the event was a two-million-dollar extravaganza! Talk about pressure. They gave me no indication how huge the wedding was to be, with five hundred and thirty-nine people. They wanted to keep things below the radar. My newspaper and wedding experience helped me cover this grand wedding thoroughly.

### Do you share the images you've captured with clients and guests as you shoot?

When people want to see what I've shot, I'm reluctant, but when I want to instill confidence in the bride at the beginning of the day, I'll show a stunning portrait or two of her on my LCD. This way, she loses her doubts and inhibitions.

### Describe your approach to scheduling sessions.

Before shooting digital or doing seminars, I worked from home for eight years. Now I enjoy doing sixty weddings a year, scheduled Friday, Saturday, and Sunday. I book weddings twelve to eighteen months in advance. I have an uncanny memory; I know nearly every Saturday booking from mid-March through December. I have very few days off during the year.

I'm usually the first client contact, and I maintain a high level of visibility. I try to communicate who I am, and when I'm successful I book them if they have the money.

### How do you handle retainers and fees?

I only require a $1000 nonrefundable retainer. I realize that's a low figure, but I love big checks near the wedding day. It's one of my little quirks.

I base my coverage on an eight-hour shooting day, with overtime after that. I give clients seven hundred to a thousand finished, tweaked 4x6-inch proofs, which my clients tend to expect. I also include a matted Leather Craftsman bound album with fifty images with most packages. Additional images are paid for separately. That's the base of my customized package and most people buy ten hours, with one hundred photos in the album plus parent albums. I don't travel much, but it's an additional charge when I do.

### What are your thoughts on client contracts?

I won't offer a contract unless I earn my regular fee for a full day's work, as opposed to half days, which people sometimes request. The only time I'll negotiate, or discount, is for an off date or if the date is approaching quickly and I'm afraid I won't book it otherwise.

I've never had a client balk at an agreement. My most important clause concerns the rights to my images, rights to use them for advertising, an act of God clause, and some other minor terms. I've had four or five cancellations, and all I kept was the retainer. If you make a client pay a cancellation fee, even though it's in the contract, you create bad blood.

### What equipment do you favor?

I have been a spokesperson for Nikon, the brand I've used for twenty-six years. I travel with a ton of gear including the new Nikon D3, and I use seven or eight lenses throughout the day. Occasionally I use Nikon SB-

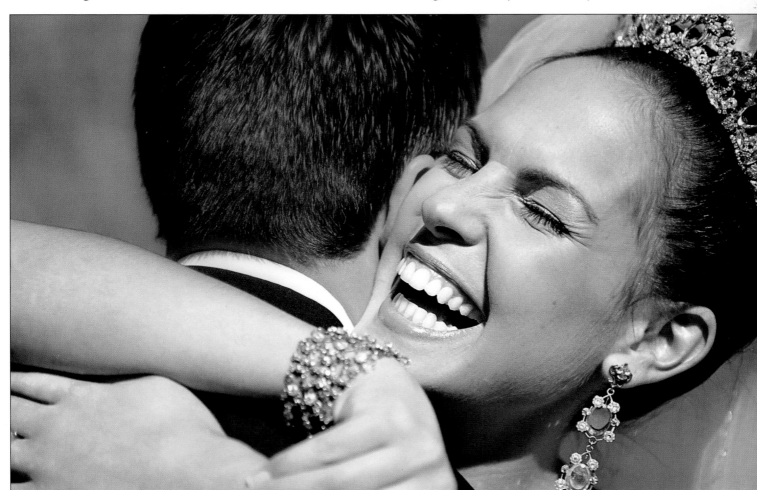

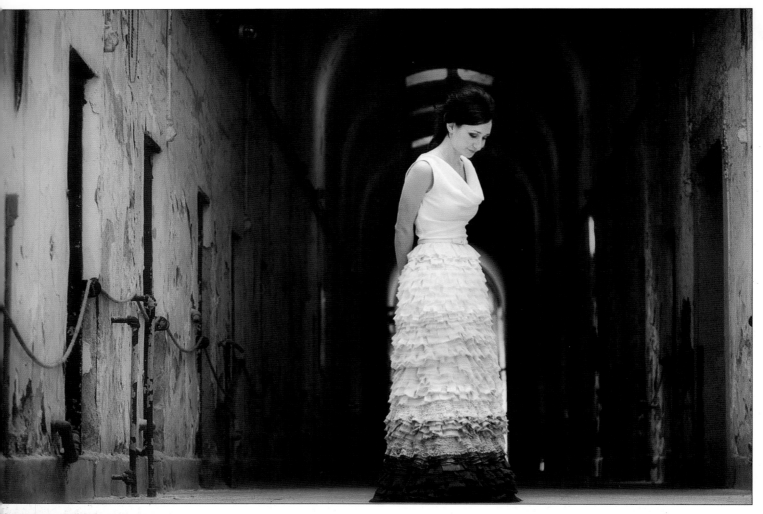

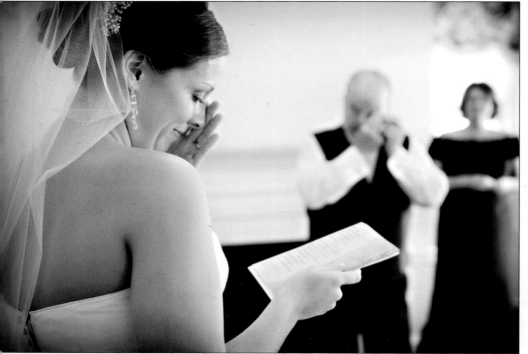

800 flash, but only off the camera via a cord, or remote. For formal portraits I'll use Profoto studio strobes.

### Describe your photo timeline.

My timelines are near perfect. I've never been late, and I've always gotten the pictures I needed. Many of my couples meet with me for pictures before the ceremony. I shoot many Jewish weddings where the cocktail hour immediately follows the ceremony and time is an issue. So I begin with the bride about four hours before the ceremony. I shoot forty-five to sixty minutes with her getting ready. Next, I capture the bride and groom seeing one another for the first time and

spend about sixty minutes with them. Then I take family photos, after which is the ceremony. For me, this makes a perfect progression.

### Do wedding photographers have recognizable styles?

I believe a wedding photographer can develop a personal style. I constantly tell my students that the only way to develop one's style is to know thy gear. If you don't, you'll end up concentrating more on the exposure, focusing, and other technical elements instead of light, composition, mood, texture, and dimension. Photography is a two-dimensional medium. When you can create images that have interesting light, you create an added dimension in your image every time.

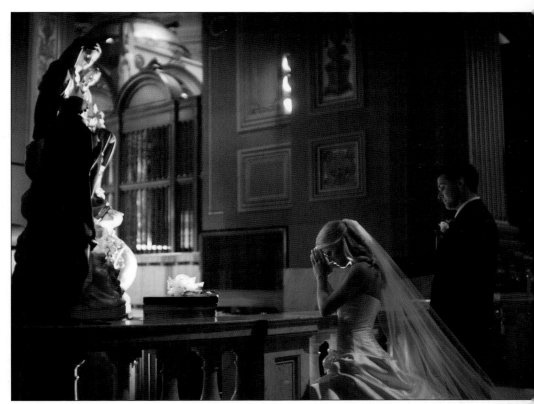

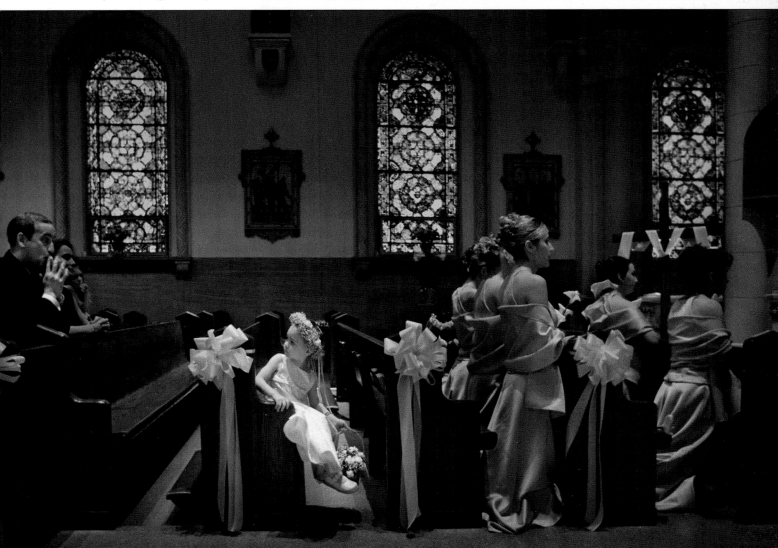

Without great light, you will get average images in most cases.

My particular style is fairly recognizable. I love to use harsh, direct light and create texture with backlight and rim-light. I have no problem overexposing highlights or losing shadow detail if the image is striking. I love graphic images, and I achieve them using light in various unorthodox ways.

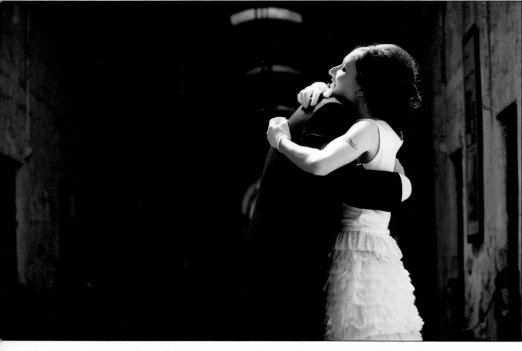

### How do you handle your workflow?

I shoot raw files and my wife, Ann (my studio manager), edits them, color and density corrects the selected images, converts them to JPEG, and carefully tweaks the images before clients see them. I'm free to network and shoot while she does my post-production work. Proofs are my best form of advertising, and the better the images are, the better they look on-line for my clients.

### How would you describe your albums?

We design our own matted albums in which I believe strong photography

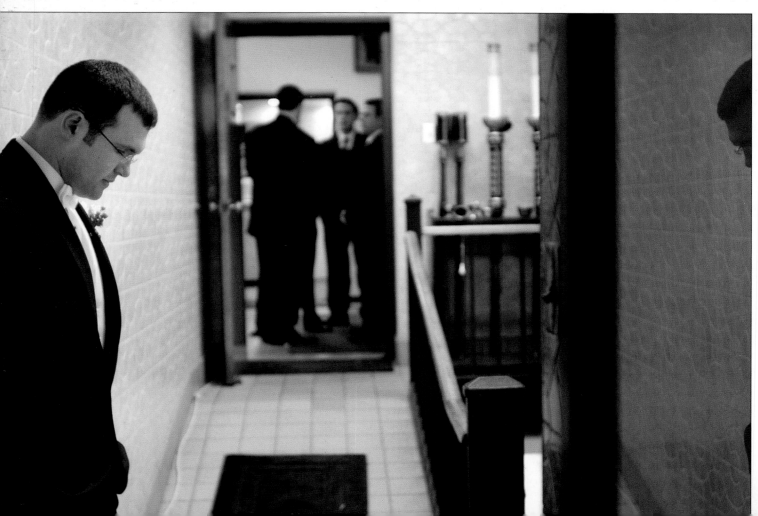

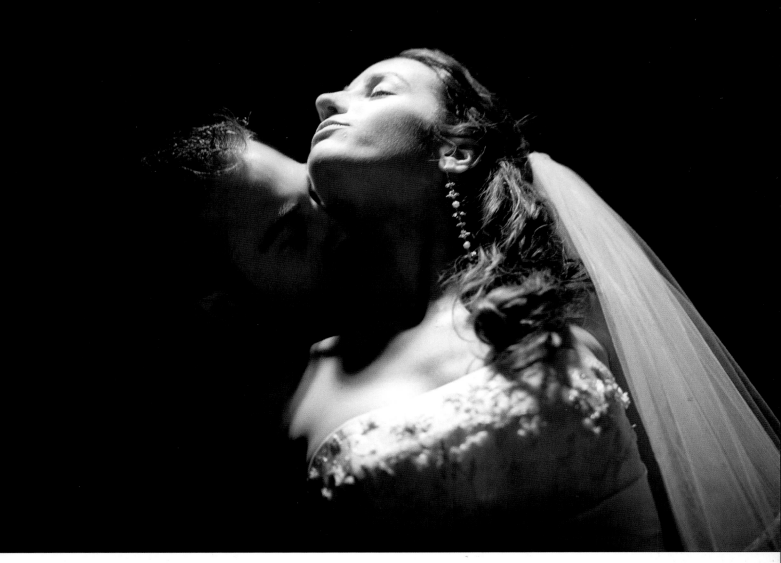

looks best. My magazine-style albums are extremely simple in design, allowing images to stand on their own.

### Is there any business advice you'd like to share?

I've never had a business plan. I have guile and I have people skills. I have succeeded despite my lack of formal business experience or business education. Strong imagery makes up for some things, but people skills are even more important. We are selling ourselves, not just our photographs.

### Is there a philosophy that guides your wedding photography?

If I did have a "philosophy," it has evolved into a fusion of various styles. The buzzword "photojournalistic" could easily have been my mantra, considering my background. However, early on I noticed how detached and unemotional my images were. Going from my photojournalism career into weddings, I took a photojournalism philosophy with me, and I soon realized that it didn't capture the essence of my couples. My approach just documented the event.

My overall philosophy includes some of the best traditional aspects of wedding photography along with my artistic interpretations of the day. I need to shoot to satisfy my soul. I can't abandon my integrity in lieu of the trite, cliché aspects of wedding photography. I'd quickly burn out. So my philosophy is to give the client the images they will value, while satisfying myself. Hopefully I'll make some images throughout a given year that feed my soul. Every once in a while, my assistant says, I have a certain look on my face. She'll say, "Ya got something, didn't ya?" That's what keeps me going.

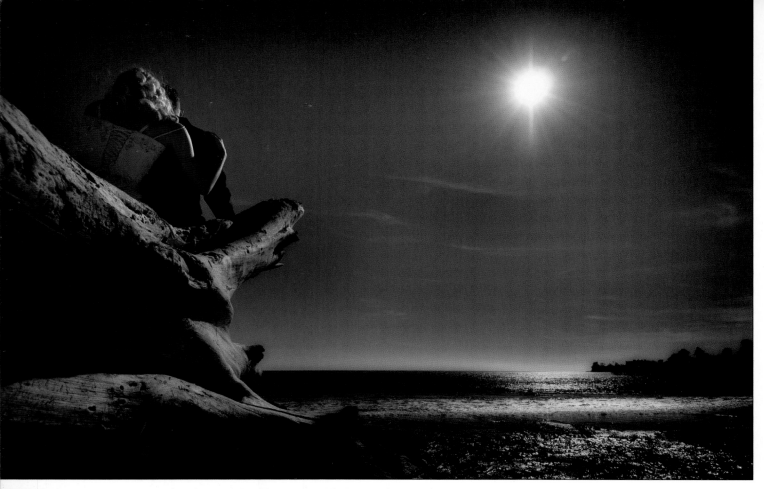

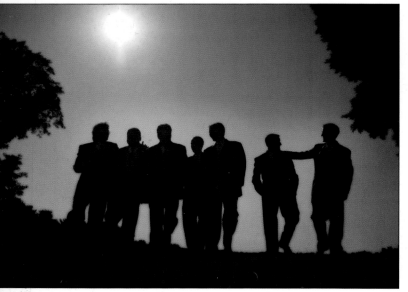

stronger in some areas, but I'm pretty comfortable in just about any situation. Beyond weddings and commercial work, there isn't much time to shoot personal work.

### What challenges do wedding photographers face?

The biggest challenges are clearly the inexperienced photographers who enter the field with little awareness. The market is so saturated with wedding photographers that those at the low-to-mid price levels will struggle to survive. Those who just make a living may look elsewhere for employment.

Lack of respect for the craft baffles me. Many wedding shooters seem to point the camera and press the shutter release, rather than see. Some are formula driven, recipe motivated, and homogenized. The result has devalued wedding photography. On the other hand, many insightful photographers enter our field with stunning talent. I feel there is a checks and balances system in place allowing the best to survive and the rest to wane. It's a type of natural selection in our field.

Rather than look at challenges, I look ahead at a bright future that the digital world enables us to enter. It's an exciting time in photography.

### Do you shoot for yourself?

I can honestly say that I shoot for myself at every wedding. I capture the compulsory aspects of the day, and when I'm pleased, the client is pleased too. I'm much harder on myself than any client will be. In addition to weddings, I enjoy a considerable commercial clientele. From a photographic standpoint I feel diversity is a blessing, and I've shot just about everything. I may be

# 6. DANE SANDERS

Dane Sanders of Southern California is a former college professor who has an undergraduate degree in marketing and a graduate degree in philosophy and ethics from Biola University. He taught leadership and character development at Westmont College in Santa Barbara. In a career switch he learned the art of shooting weddings from another photographer, David Jay, and became entranced by doing wedding-day reportage. He says he puts emphasis on dealing with emotion and the unexpected. Dane's background and photographic skills have made him popular with clientele in and out of California.

**Describe your background.**

I did not study photography formally except for a couple classes in film shooting and Photoshop. I'm self-taught and have worked with some pretty amazing shooters. From them I learned the intangibles that everyone wishes they could get in college. They were like life courses on how to become the person you knew you were supposed to be if you wanted to be super successful but didn't know how to go about doing it on your own.

My interest in photography came from wanting to take better pictures of our first child. I couldn't afford the

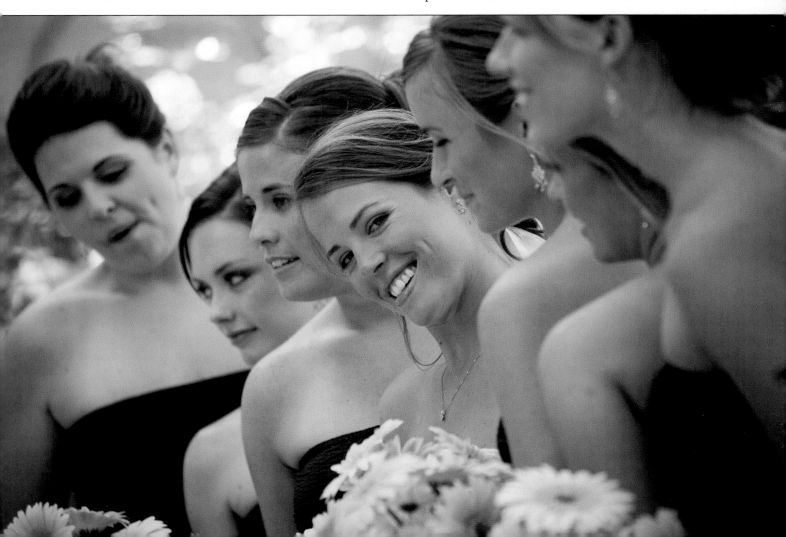

equipment, so I started assisting one of my overachieving leadership students, David Jay, who was getting into weddings. I quickly became his photo student.

I still photograph my wife and four kids of course, and I like to shoot photojournalistically whenever possible. Fortunately I've had opportunities in the last few years to visit South Africa, New Orleans (Katrina relief), and India. Street photography is a blast, and I try to imagine what the Cartier-Bressons or James Nachtweys of the world would find interesting, and go after it. I struggle to not make shooting my exclusive work in life, but I love taking pictures and want to maintain that affection through embracing subjects that I feel called to.

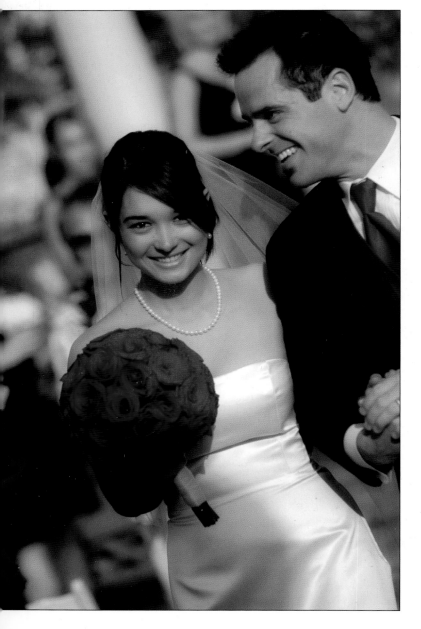

### How is your career evolving?

Shooting professionally for five years, I've specialized in weddings from the beginning. I established a nice pattern of either shooting or working with other up-and-coming photographers. On my own my career evolved organically. My first gig was shooting a wedding for $1500, and I worked harder at that event than maybe ever since. I am hooked by the thrill of a time-sensitive event, and seeing guests' immediate gratification when I show my images at a reception slide show.

### Who are your influences and mentors?

It was the great photojournalists who demonstrated the adventures of photography for me. The images and feelings they produce are absolutely mind-boggling. Photographers in the early days of Magnum, and now VII, are just jaw-dropping. Now with the advent of an artistic spin on photojournalism within the wedding world, Joe Buissink, Parker J. Phister, John Michael Cooper, Jessica Claire, David Jay, and David Beckstead are among my inspirations.

### Describe your studio and/or office.

I don't shoot at my home studio, which is primarily a place for postproduction, office work, and meetings with clients to present my work. I also meet with clients online through my video interface. Clients can also log on to my web site, watch videos of me, and see "what to expect" in the details section of my web site, http://danesanders.com. I shoot on location 99 percent of the time, so my "studio" needs to be portable.

Weddings take me to widely situated places in Southern California and along the whole west coast. These locations make my photographic life simpler because working conditions are often perfect. East coast shooters may have a harder time when the weather is wet or snowy.

### Describe your approach to scheduling sessions.

I outsource everything I can to free myself to shoot whenever I want to or can. Now that I know exactly what I require out of postproduction, I'm increasingly sending that work to an outside company with which I work very closely. Professional designers also do my print fulfillment

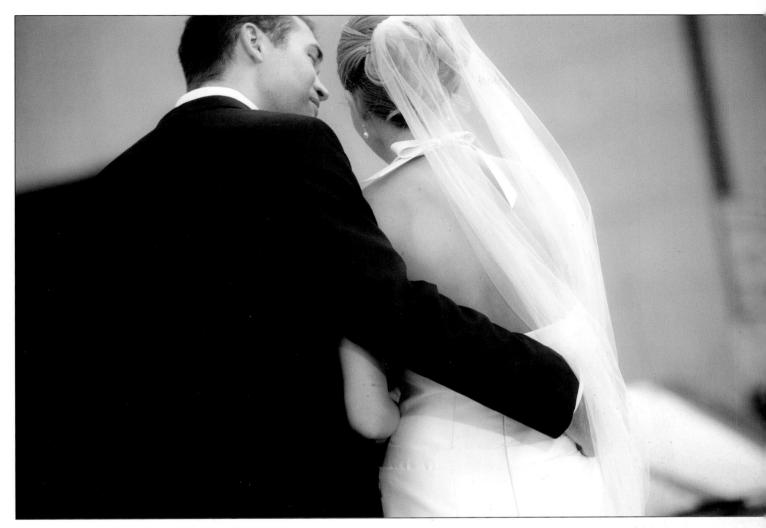

and albums. In this way I can spend time at weddings and personally connecting with clients.

Weddings are scheduled mainly on weekends. However, I'm noticing that more clients are getting savvy and creatively stretch their budgets by avoiding prime time. Their unique wedding experiences at alternative times during the week are less costly.

I schedule from eighteen months in advance to perhaps a month before a wedding if I'm available. I keep track of jobs on a calendar where identifying names are posted. I do not schedule a wedding every weekend in season because I'm not high volume. I shoot no more than twenty weddings a year.

I charge a 50 percent nonrefundable date reservation fee when I book. The balance is due thirty days before the event, and it's often automatically charged to the

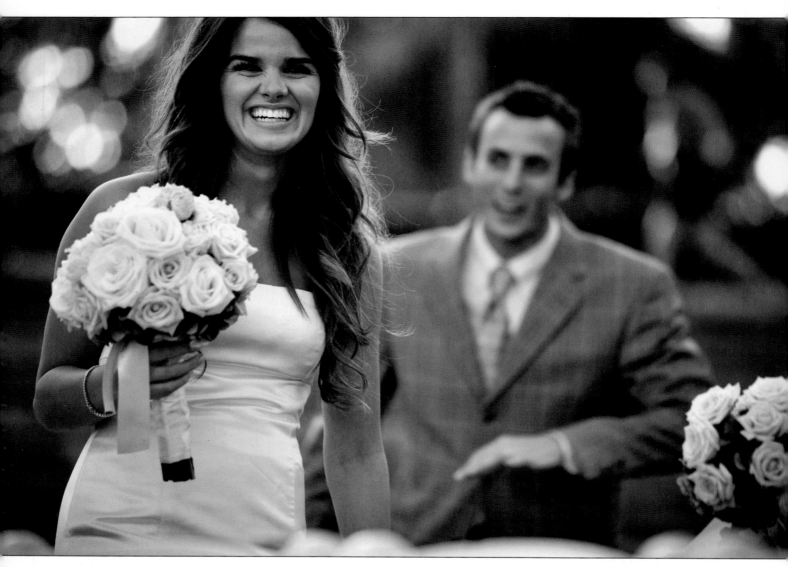

client's credit card through my relationship with Pictage. It's a great service.

Partial return of a retainer is granted on a case-by-case basis. Legally, I'm not bound to any payback, but I have made refunds in the past and was glad I did in those specific circumstances. For example, one client requested a refund because his fiancée ended the relationship, and I complied. A few months later, a mutual friend told me that this client had taken his life. It was a tragic experience, and I'm glad to have been freed from later guilt by giving this guy a break. Everyone needs a break at times, and I feel my making a payback is related to the breaks I've received over the years.

I don't advertise a "full coverage" fee, and after my relationship with clients begins, I outline in detail what my fees include. My clients tend to respond best to the premium fee and not being nickled and dimed later. As for travel, hotel, and meal expenses, my clients tend to assume these are separate, and they never become an issue.

### What is your view on contracts?

These protect the photographer and the client from disappointing expectations. When client expectations are reflected in contract stipulations, my experience indicates there is rarely a problem.

### What is it like to collaborate with your wife?

I collaborate in raising our kids and Tami shares making business decisions. She supports me best by not shooting with me, though she is an incredible ally. She's more of a board member in my business, and her separation from

day-to-day operations gives her a very useful perspective. She helps me remember that shooting is not my whole life, and that I can retain my love for photography by not being enslaved to it.

**Do you shoot locally or on location?**
Three years ago about 80 percent of my events were local. Now clients are discovering how doable it is to employ photographers they want wherever they want. In 2007, about 60 percent of my weddings were out of state. Since I began shooting professionally, the landscape of wedding photography has really shifted. The ease of entry for new photographers has expanded dramatically. Prices for generic (basic) wedding photographers are going down like commodities, but for known photographers, fees are going up like designer clothing. Location shoots are easier to sell, although I don't know if I'm selling or if clients are going after who they want.

More creative business partnerships have evolved, meaning the traditional vendor relationships with companies like labs, etc. For instance, I consider Pictage a partner in my business, and we work hard to help each other out. I speak for them and love to endorse them publicly for all they've done for me. They treat me well, and everyone wins. I have similar partnership relationships with liveBooks (for my web presence), Albumesque (for my album design), and ShootDotEdit (for my postproduction).

Photographers who've leveraged the Internet and video have discovered the advantages of creating a following quickly. That is, of course, if they have the talent

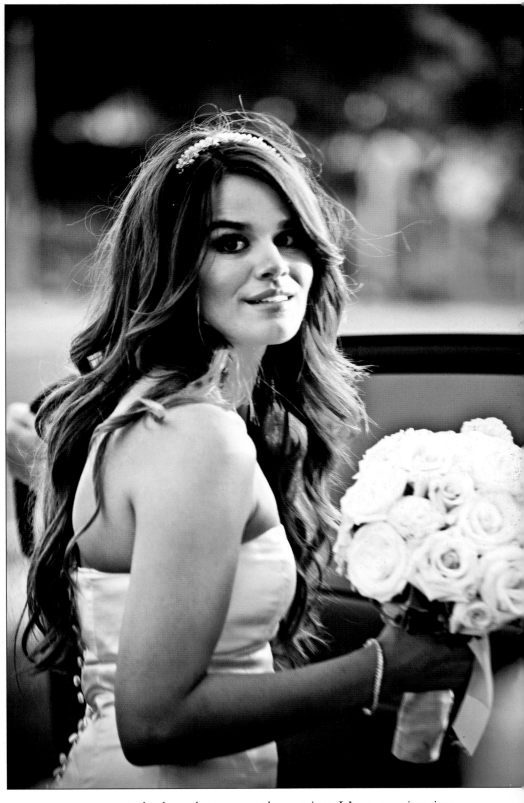

to back up the message they project. It's an amazing time to be a photographer, perhaps the beginning of a golden age.

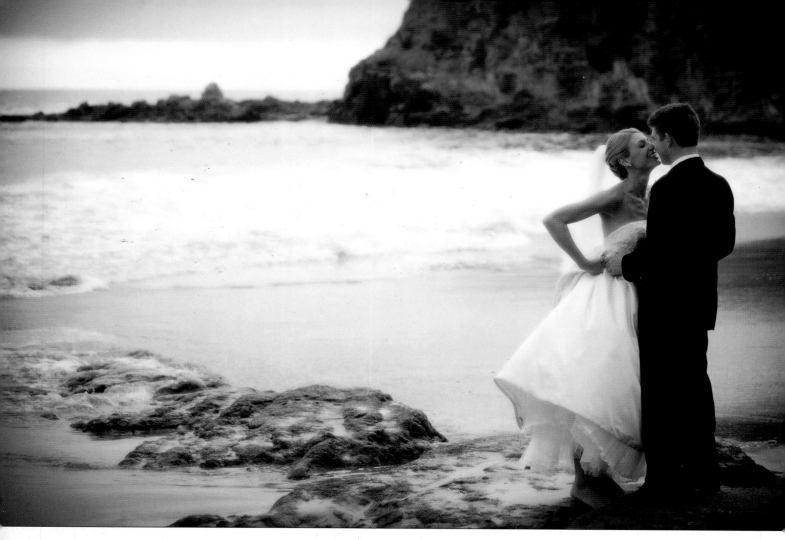

of being face to face. The video pre-meeting is a plus that raises the value of our later in-person meeting.

Though the couple has been impressed by my web site and probably by wedding pictures I did for their friends, they still want to know if I'm available for their date, and what they're getting for their investment. As I said before, when you've found a way to be distinct in the industry, prices should continue to rise.

### Do you have any tips for handling the unexpected?

On every wedding day you will probably deal with the unexpected because each event is unique. Weddings offer the best kind of melodramas, such as managing guests' and couple's expectations in the midst of rain. I'm flying to Connecticut for a wedding soon, and thunder storms

### How do clients find you?

My web site is critical. I include videos on it that basically mimic what it would be like to meet with me in person. This makes an emotional connection with clients and generates expectations while removing the burden

are predicted. Factor in angry mothers-in-law, drunk uncles, awkward toasts, missing bridesmaids, plus other things that can go wrong. Photographers are part coordinator, part bartender, part psychologist, and always visual story-tellers. For me the rush of the unexpected makes the day so fun, and so easy to do over and over again. I love the challenge.

No one asks to see what I've been shooting because clients and guests know they will view a selection of the best pictures at the reception. That slide show is often the highlight of the day, because it allows them to relive the wedding itself. It's awesome.

I have checklists for everything to do or take, so I don't forget anything. When I figured out that refining my systems was the simplest way to efficient preparation, I could focus on what matters most, with administrative tasks accounted for. I use American Express services for reservations, etc.

**What equipment do you favor?**
These are my main tools:

- Two Canon camera bodies, 5D and 1D MK II
- I prefer prime lenses, but for convenience I carry three main zoom lenses: wide-angle, portrait, and telephoto, plus fisheye and macro. I carry extra batteries, memory cards, and my Canon 580EX speed flash units used both on and off the camera. In low light levels you can boost ISO numbers and do lots of things with slow exposures if you're clever and steady.

- I have used studio strobes to cover large areas, but they are often too laborious and don't allow me to be as nimble as I prefer.

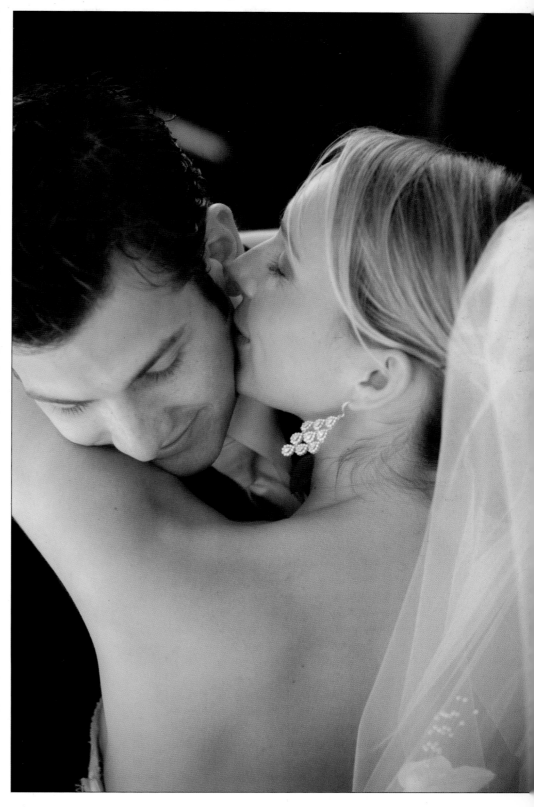

I have a system for everything. Simplicity gives me the freedom to be creative, and I try my best to be ruthlessly disciplined.

### Do you visit the location prior to the event?

Previewing is rare for me. As a result, it can be fun to get creative about locations on the wedding day when much of the photography depends on the light, which can change frequently. Flexibility really makes a difference.

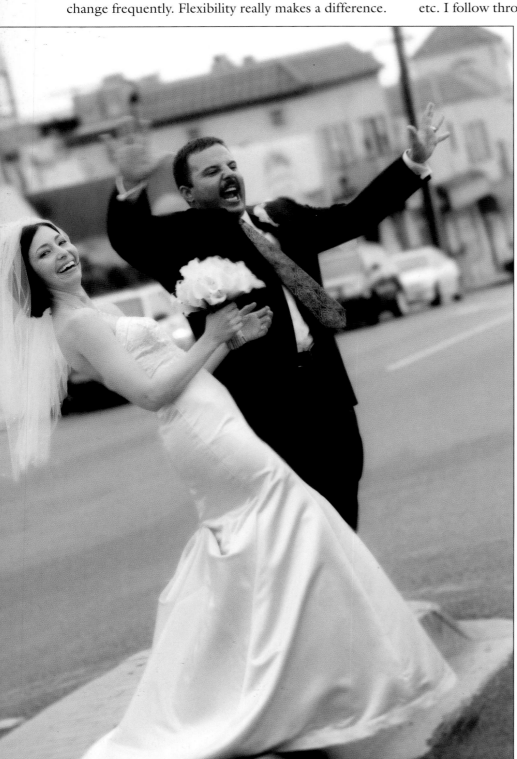

### Describe your photo timeline.

I help clients before the wedding to share their expectations about how their day will flow, but on the day itself, I just go with the movement of events. I do shoot in a timeline to tell the best story, which is set by the clients themselves.

I consider ways to market the event through coordinators, magazines, more blogging opportunities, videos, etc. I follow through on those after the couple has experienced the album pre-design for a few days. Then I release the online proof prints. My album designer (who is on retainer) works back and forth with the clients until they're totally stoked and place their order. I then surprise the clients with a free archive DVD of all their images.

### How do you handle your workflow?

I back everything up and create the wedding reception slide show the night of the wedding. I choose my favorite fifty or so images while wedding guests are dining. Afterwards I show the pictures discreetly in a corner of the room. Guests "discover" the slide show playing on my laptop and go crazy. I also upload the chosen few online and to a wedding blog. A week later I do the big edit and retouch when necessary, then convert from raw to JPEG. I prepare the album pre-design for delivery when the bride and groom return from their honeymoon.

### How are your images presented?

The couple views their pictures online, through video slide shows and their album pre-designs.

Regarding black & white, I make some artistic choices and Pictage makes color adjustments as requested by clients automatically online. When I edit images, I choose only the best

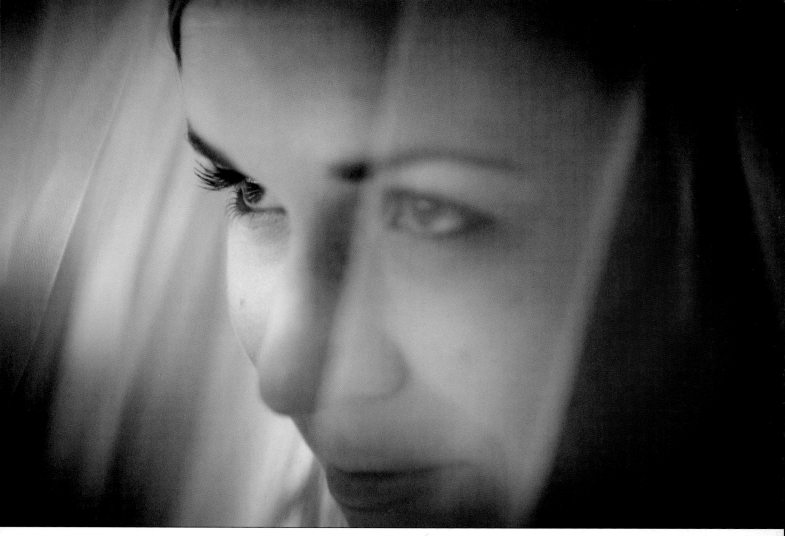

pictures to show and present an average of eight hundred to one thousand images.

Prints are usually priced separately and only occasionally are they included in the basic fee. I rarely offer anything larger than 8x10 inches. If they want larger, they're welcome to get them through Pictage.

### How do you promote your business?

Except for my web site, word of mouth, and the appeal of my slide shows, I don't undertake other promotions. I maintain my own web site.

### Do wedding photographers have recognizable styles?

I feel that wedding photographers can and must develop a recognizable pho-

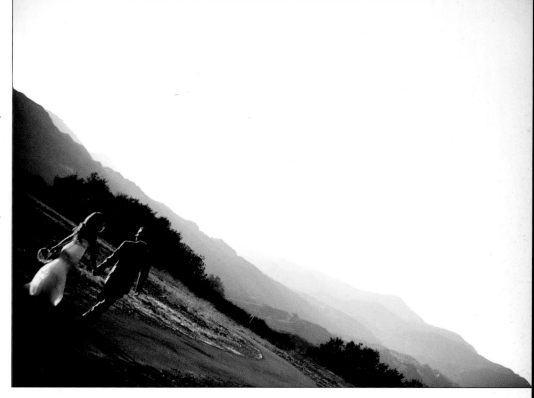

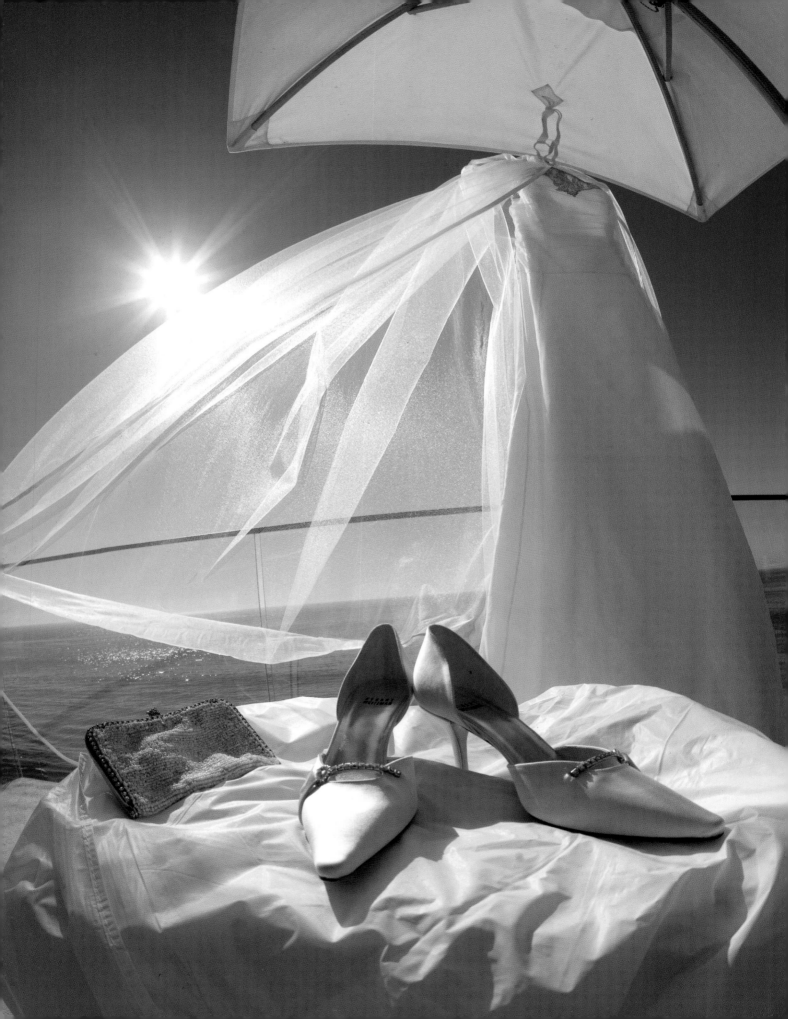

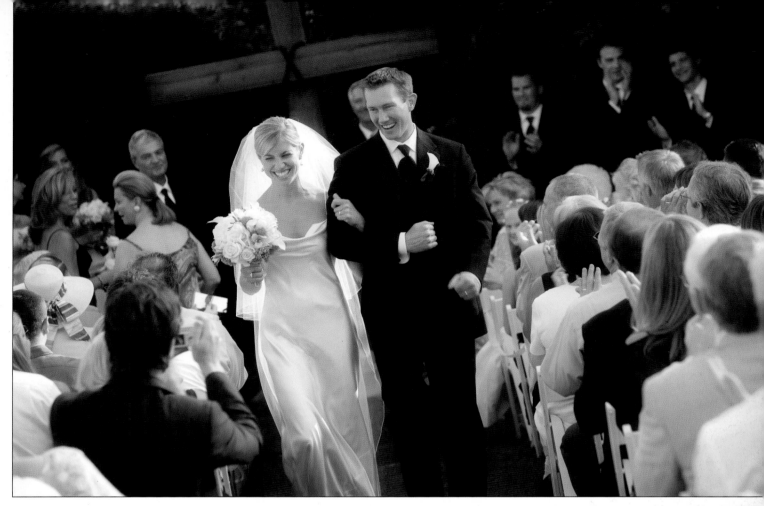

tographic style. It's a storytelling genre that can be very powerful. Pictorial style can be compared to methods of master storytellers who use words and work with different voices and gestures. Our medium can do it with images. Realize that individual artistic approaches are involved in your images.

Be distinct or be extinct. It is absolutely critical.

### Is there any business advice you'd like to share?

I made some important business decisions early in my career—to outsource services, simplify methods, and create an atmosphere to focus on what I do best.

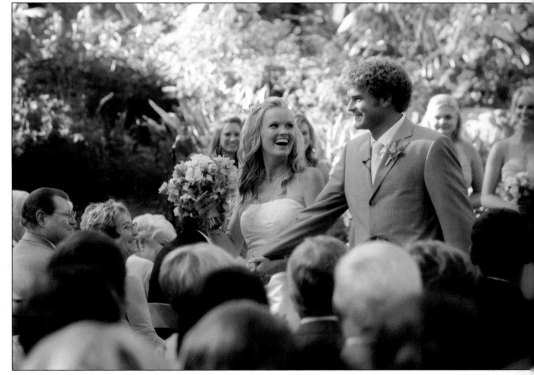

You should review your business yearly. I review it daily, but it's less about the plans (though those are important) and more about vision and values relating to what I am doing and why I'm doing it. Responsible vision and smart values should inform all your choices. Pay yourself a salary. I'm incorporated, so I have to.

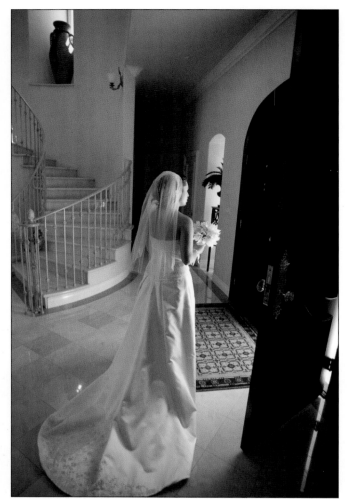

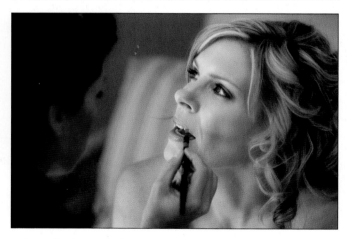

When photographers fail in business it is often because they limit their creativity to photography and put much less effort into their business.

I realize that some photographers are more idealistic, sentimental, emotional, or casual than others. I'm tuned to simplicity in the midst of complexity. It allows me the space I need to breathe and keep perspective. I love being creative and being around the emotion of life-changing moments that wedding photography offers. It's a gift to be in this industry.

**What challenges do wedding photographers face?**
The pace of change we face today requires us to embrace the opportunities that our era offers. Change is inevitable. Those who resist it will fail. Those who accept it will flourish. For me, negotiating change well is the most creative part of this business and certainly the most motivating.

Jennifer Dery lives and works in San Diego, CA, in a beautifully remodeled studio she shares with her husband John. Having had a love of photography in her teens, her passion for the craft grew as she reached her college years and beyond. After a short period photographing children, she made the move to weddings where her competitive nature and love of new adventures has helped boost her success.

**Describe your background.**

My family was avidly into photography and video, and my parents made sure I always had a camera at my disposal. I used one of my grandfather's older cameras to capture my first award-winning image, which won Best of Show in my category at the 1987 Del Mar, CA, fair. That early recognition was very encouraging.

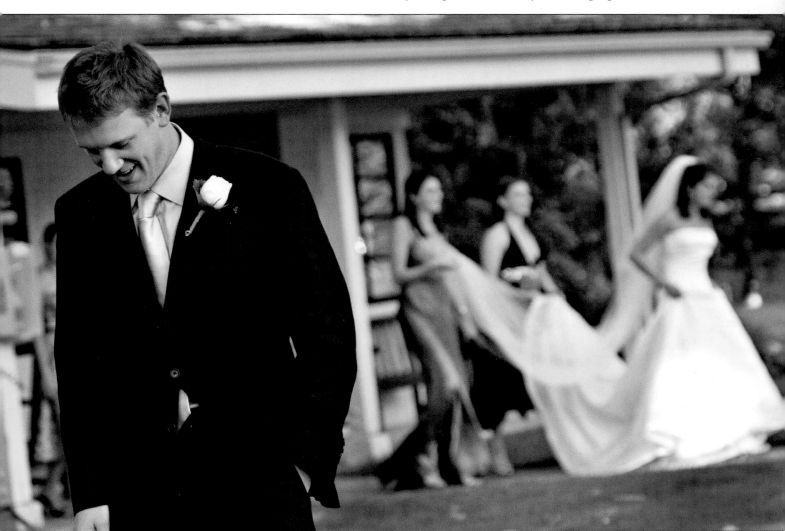

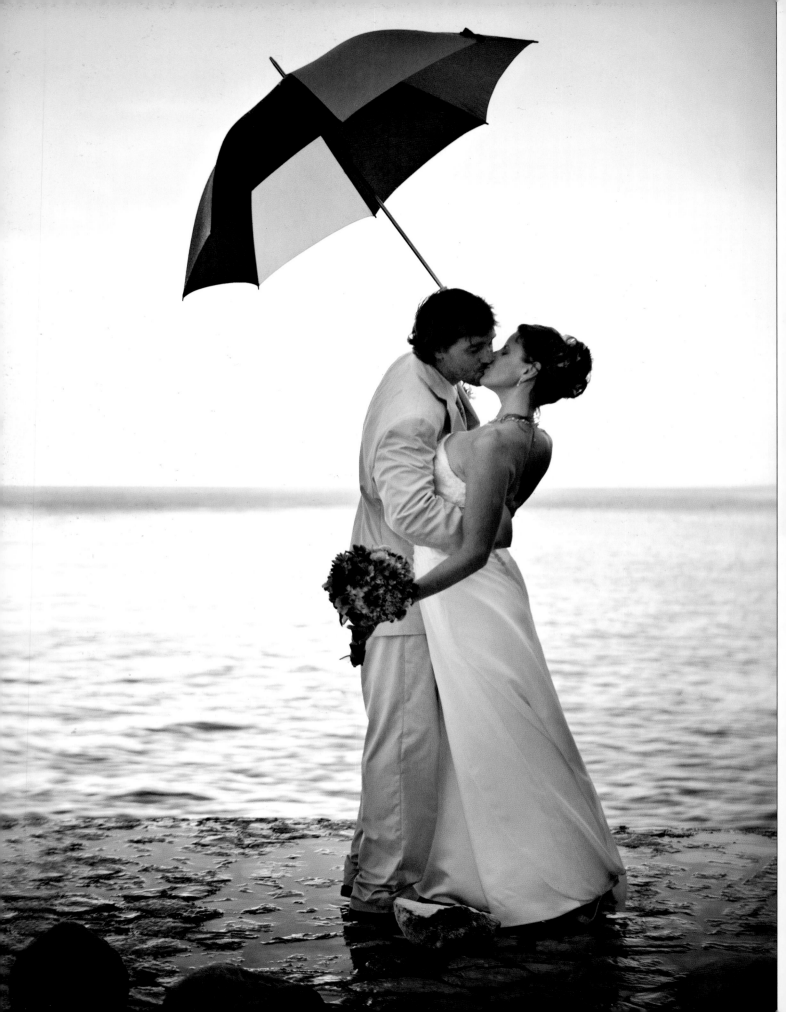

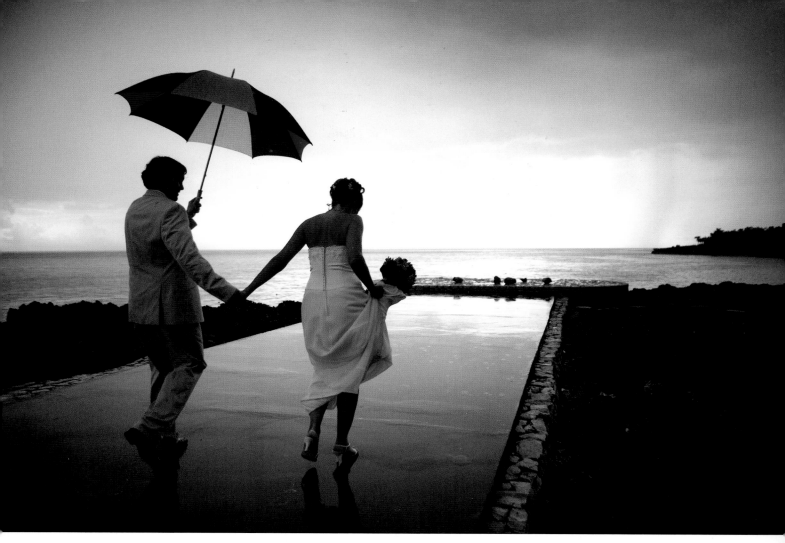

In my college years I gained valuable skills that helped me immensely in the wedding field. A psychology degree has given me great insight into communicating with and understanding my clients. My time spent as a server for a fine-dining restaurant taught me sales and communication skills in a real-world setting. And later my work in catering gave me knowledge of the wedding business as a whole.

### How has your career evolved?

When I first decided I wanted to be a photographer for a living I started building a children's photography business. After a while, however, I found that just doing child portraiture was not challenging enough for me, so I shifted my focus to weddings. I found the change in subject matter to be much more interesting. Weddings also offered opportunities to create a greater variety of beautiful images.

Part of what helped me make my creative shift was analyzing the few weddings I had already done. In re-searching my market, I realized I was as good or better than a lot of the San Diego competition in 1998. I'm a competitive person and discovered a big niche I could go after.

While building my wedding business I always had a "day job." The last one was working in sales for a catering company. I learned so much about working with brides and gained a valuable education about the local wedding industry. By 2001, I had quit that day job and went full time into photographing weddings.

### Who are your influences and mentors?

Starting out, my biggest mentor was my dad who excels at "technical stuff" and loved my questions when I was starting out. Even now we'll get into a discussion about new software or critiquing his new images, and we can easily drive my mom out of the room. It is wonderful to share a common passion with him.

Nowadays I frequently peruse magazines and art books where I find new inspirations for my work. The

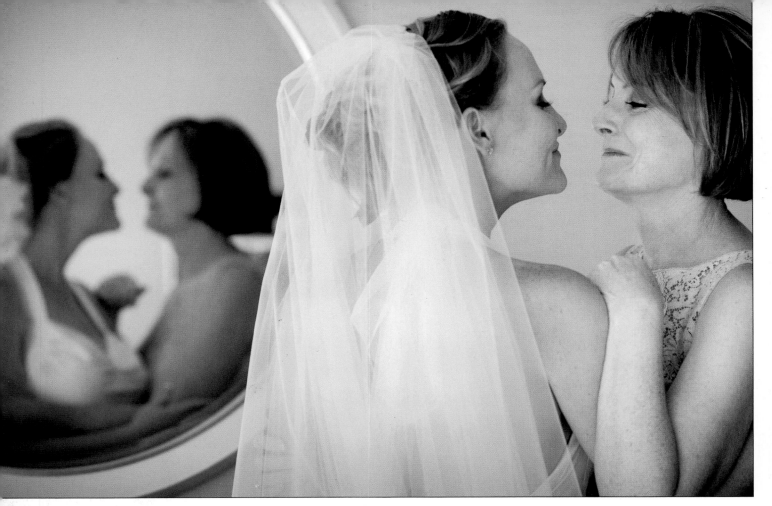

only wedding photographers' work I study, however, is my husband's. John pushes himself to grow in his art, and I push myself right along with him. We have a fun dynamic going on.

### Do you shoot locally or at more distant locations?

About 20 percent of my work is destination weddings. The rest are in the Southern California area. Destination inquiries have grown, but budgets for them, in general, can be really small, so I am very choosy about what I take.

Because of the Internet it can be easy to consult with destination clients, though in this personality-driven profession I find clients really want a connection with their photographer. It's great to connect over the phone or by e-mail, but often clients need to meet in person, and I'll do what I can to make that happen.

My local market is more lucrative than the destination market, particularly when I can book two or more events and portraits in a week in my area, compared to one destination event.

### How do clients find you?

Just as in any business, our clients find us through various marketing and promotions we do to support the business. Potential clients find me through my web site, vendor lists, coordinators, and personal referrals.

### What's it like to have a spouse in the industry?

John and I met at an industry event and it was more or less love at first sight. In the typical head-over-heels scenario we were soon engaged and trying to figure out what our businesses would look like after marrying our competition. In the end, unlike most photographer couples, we chose not to combine our businesses. We book and shoot our weddings separately, under our personal business names, but in a fun twist, we share a single studio space and two full-time employees.

Merging our businesses was not wise for us because John and I were separately successful and had both worked hard to differentiate ourselves from the crowd. We are also both very hard headed and are used to being the boss of our own studio. Combining would have created more trouble than it was worth. Separately we can

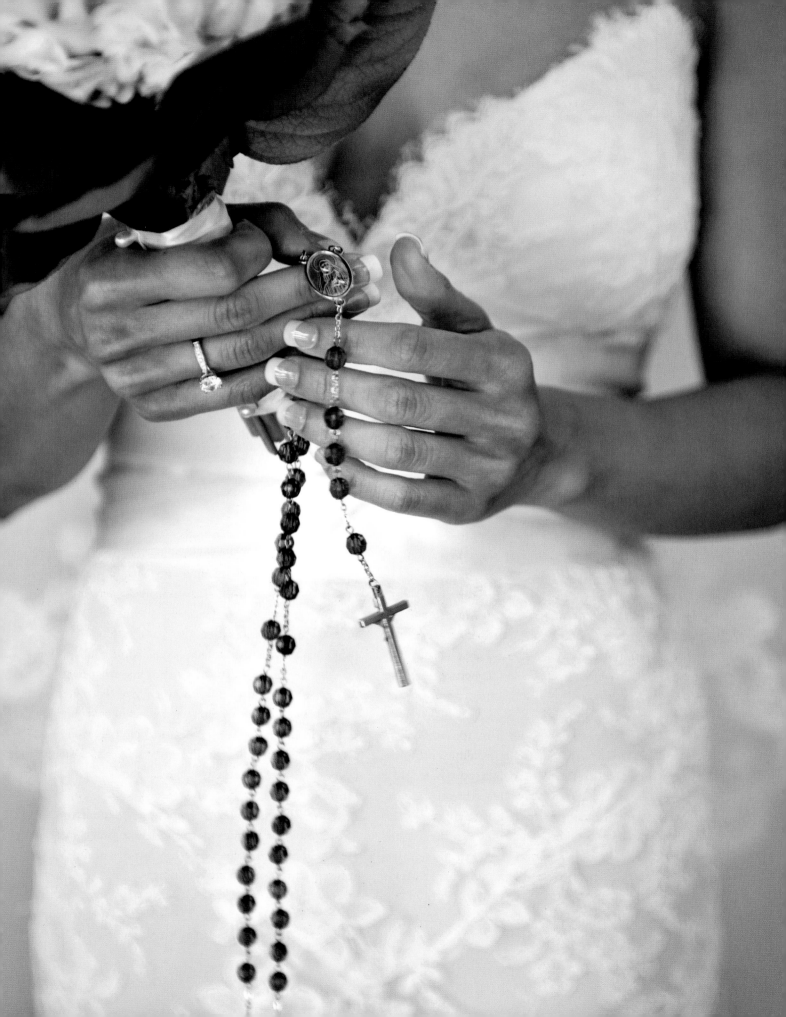

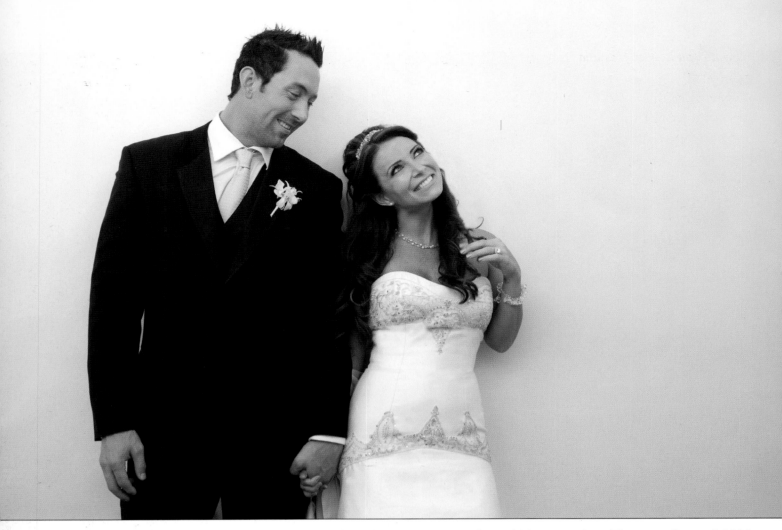

bring in double the number of weddings, and we don't have to agree on every move we make. This decision has probably been at the root of our staying happily married.

### Describe your studio and office space.

Our studio houses our wedding businesses plus our portrait division, which is run as a joint venture with our staff. There are three of us shooting sessions and another helping with sales and marketing. We have a nice daylight studio for most of the baby shoots. I use the studio's big north window as my main light with the skylight for fill on short, darker winter days. I may add a strobe to the mix. I find big flashing softboxes scare the little ones, so I tend to bounce flash with reflectors and mix it with available light. Small children are photographed in the studio, but all weddings, engagement sessions, older children, and family sessions are done on location.

We bought our building in 2006 and fully remodeled the second floor as our studio and offices. Our shooting space is about 800 square feet. The rest of a total 2200 square feet includes a meeting room, four offices, and a production room. In the future we plan to convert the 2200-square-foot bottom floor into additional shooting, meeting, and storage space.

We have two full-time employees who handle all our production and customer service, plus three part-time employees. They help us with everything from growing our portrait business to doing errands and bookkeeping. John and I learned that if we wanted to have a life outside the studio, we had to delegate non-crucial work to others.

### Describe your approach to scheduling sessions.

I will contract weddings up to eighteen months ahead of time, and potential client meetings up to a month in advance. I do about thirty weddings a year, plus about twenty engagement sessions. I do a handful of portrait sessions per month as well.

### How do you handle fees and retainers?

I charge one third of the total contract, and retainer refunds are generally not given. The first retainer payment is required with the contract, the second is due four months prior to the event, and the final is due ten business days prior to the event.

My fees are based on the time it will take to shoot the wedding, plus the album and any extras requested. I offer "coverage only" options as well as full-service packages. Travel, meals, and hotel are all quoted as part of a full-service package.

### Do you use a contract?

My husband fancies himself a legal emissary, and he has developed our own contract with the assistance of our attorney. More comprehensive

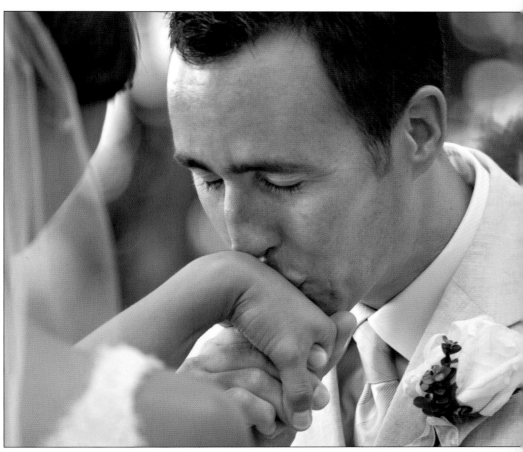

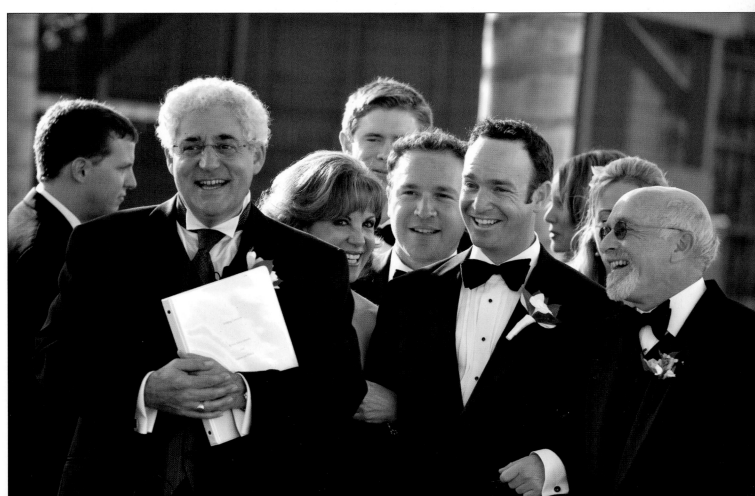

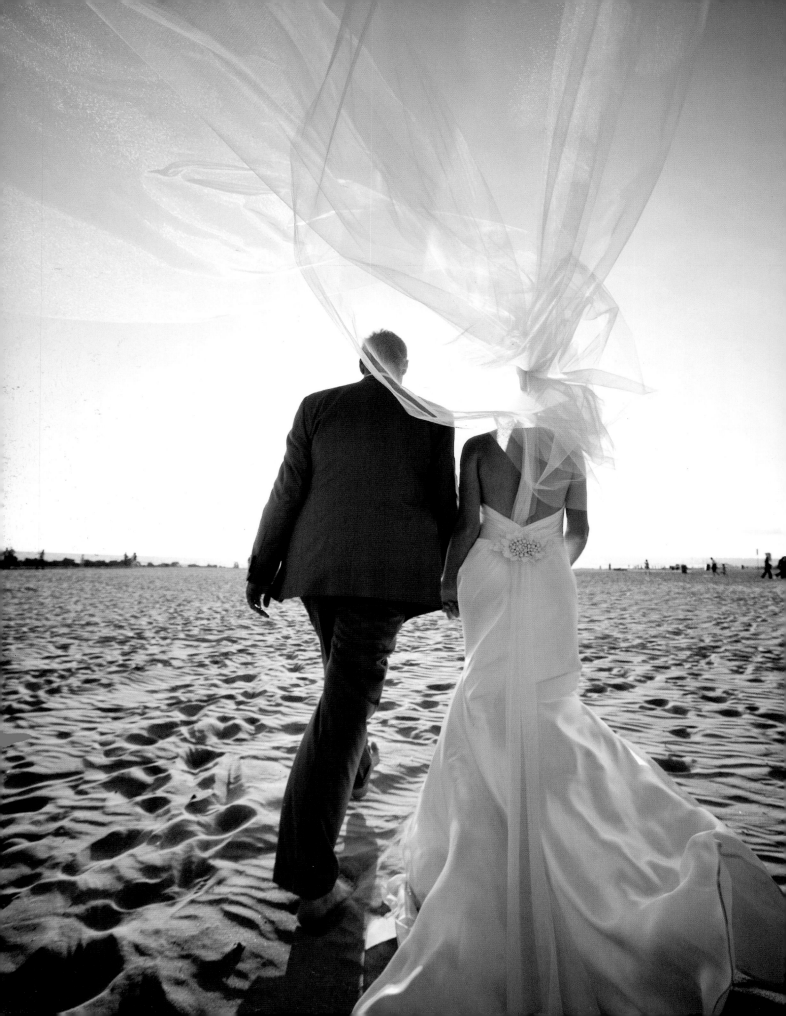

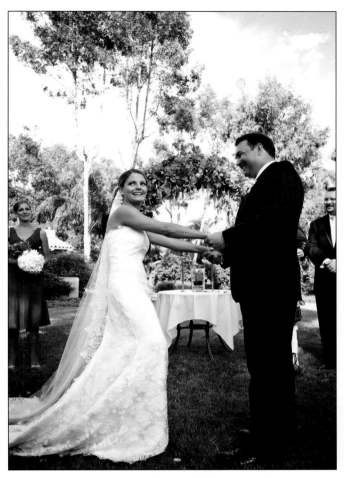

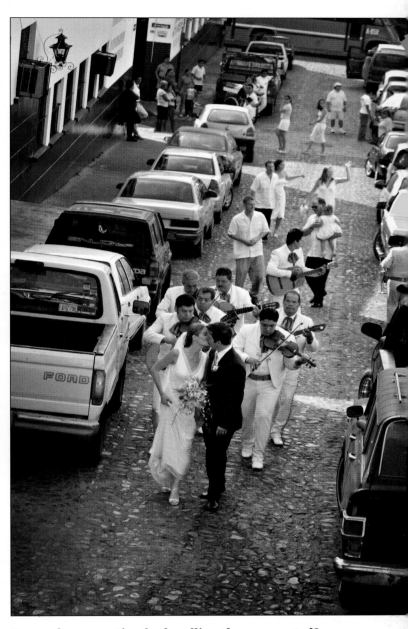

than the average photography agreement, we feel it may be the best in the industry and a write up in *WPPI's Photography Monthly* ("The Best Wedding Photography Contract in the Business" July 2007, vol. 31, no. 1) agreed. We have also made our contracts available to other photographers and are doing well with that also.

### What steps do you take to prepare for the event?

I prepare by going over the timeline and checklist with the client or coordinator the week prior to the event. I check equipment and batteries, drink a lot of water, and get a good night's sleep—and I make sure to never eat anything questionable the day before an event.

In San Diego I generally do not preview locations as I've been to nearly all of them already. For destination events I scout at the same time of day I plan to shoot.

I use all Canon camera equipment and try to keep my kit as small and light as possible. Between my assistant and I we can carry everything we need while shooting.

### Do you have any tips for handling the unexpected?

On the wedding day I'm a "go with the flow" kind of person. Schedules change, brides are late, cars might stall, and weather may be awful. These things are beyond my control, and I try not to add any stress to the day by having a fit of my own. So far I've been lucky; I have not yet faced a true disaster.

### Do you use a travel agent?

For destination weddings I generally make my own reservations, though I may use a travel agent for more complicated itineraries. My favorite place for pricing out travel is American Express online. Their rates tend to be

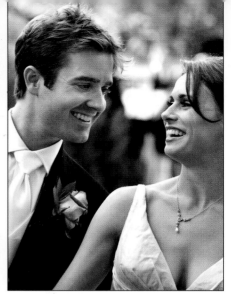

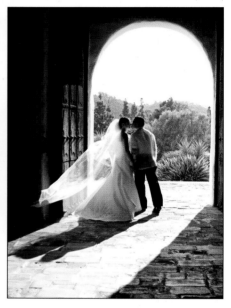

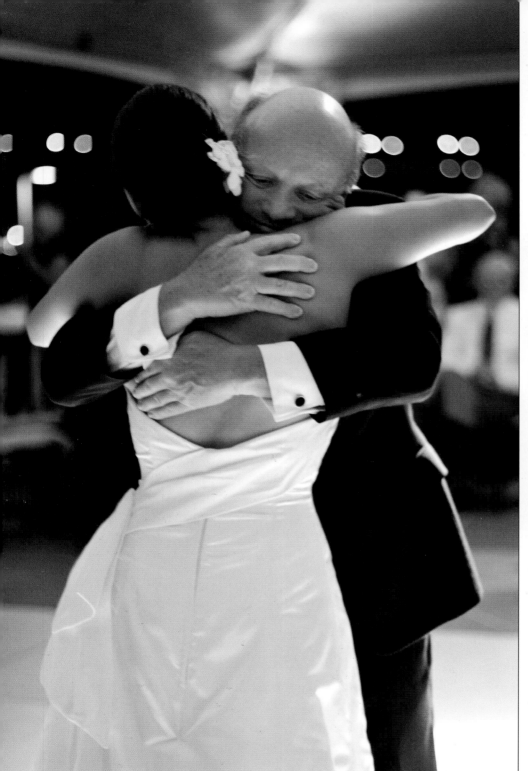

clients—agree to adhere to. I try to be the first person to create a sample timeline for a couple so that the timing I require for photography is incorporated into the rest of the planning from the start. I make a point of informing my clients that they need to talk to me before any timeline is set in stone with any other vendor.

more realistic than the bargain basement sites and you can price air, hotel, and ground transportation all at the same time. The number one thing for me when it comes to travel is that I take care of my own booking.

### Describe your photo timeline.
To have a successful wedding, it is crucial that there is a realistic timeline in place that all parties—vendors and

### Do wedding photographers have recognizable styles?
Style is that special je ne sais quoi that photographers struggle to develop and may find hard to describe. Unfortunately, because the challenge of developing a personal style can be so difficult that many photographers instead rely on copying from their peers, which I feel is bad for progressing our craft.

I feel I am still a developing artist, and I find it hard to describe my own style. It is, if nothing less, consistent. My approach is to tell the story of the day in an honest and emotional manner. Although I am of course concerned with pleasing my clients, I find the real elusive challenge is impressing myself.

### How do you handle your workflow?

Workflow is really simple. I do the parts I like such as shooting, sales, and album design, and my staff does everything else. They really make me look good and, more importantly, clients are happy to have albums on their coffee tables and prints on their walls. The most important thing about workflow is finishing it. When clients are happy and have their finished products in hand they can show their beautiful images to friends and refer us for more work.

### What means of presentation do you prefer?

We invite clients to see a slide show of a small selection of their images when they come to pick up their full set of proofs. This accomplishes two goals: (1) They see the images large and beautiful in a color-controlled environment. (2) If clients love what we show, they are more comfortable with the idea of allowing us to design their album without their input.

After the slide show, clients will take home about five hundred printed proofs, and we will design an album for them containing seventy to ninety of the best images. We post the album design online for their review, make any requested changes, and will deliver their book within three to four weeks of their approval. We have found this method helps cut down the number of straggling couples who never order their album.

### What's included in your packages?

Enlargements are generally not included in our packages, but we sell many à la carte. We concentrate on promoting what we call "fine art"

prints versus worrying about small reprint sales. My fine art prints are fully retouched and crafted to match the vision I had for that image at the time I took it.

### How do you promote your business?

We have a multi-tiered marketing program. No one avenue, such as word of mouth, would be sufficient. Many times potential clients need to see our name a few times before calling so we make sure to take advantage of every avenue of promotion we can to ensure this happens. Magazines, brochures, postcards, and personal referrals are some of the ways we make contact with our future clientele.

### Is there any business advice you'd like to share?

I believe communication is the key to a good relationship with our clients. By properly setting expectations and discussing issues that arise, we set the groundwork early for keeping our clients happy.

I do have plans to grow the business, but I do not have a formal business plan. Rather than having dreams of being famous and taking over the world, I'm more interested in improving the quality of my life and those around me. I take the time to recharge my creative energy, stay passionate about my craft, and I try not to work incessantly.

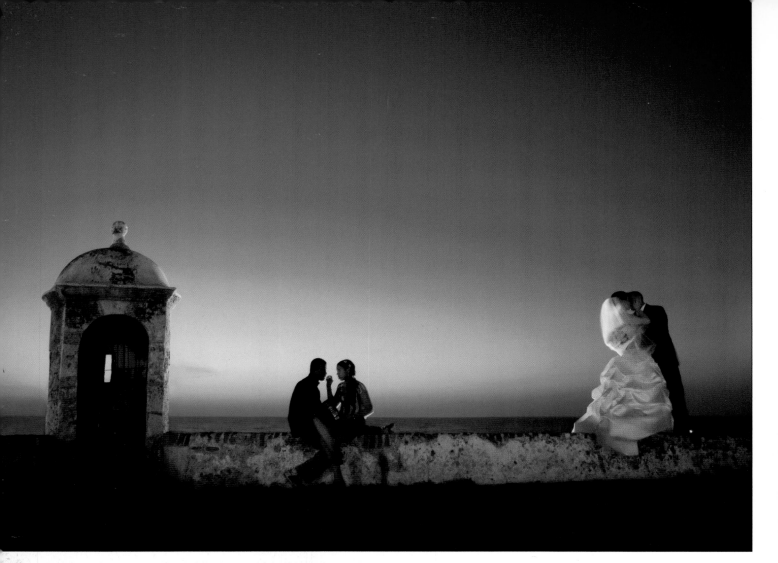

### Is there a philosophy that guides your wedding photography?

My enthusiasm for weddings is sustained by the challenge of making the familiar seem different. Weddings, as we know, are generally very similar. It is what I am able to do with each event that keeps it interesting. I make sure to always go in new directions to keep myself interested. Photography is the perfect profession for a person who likes to keep growing, because you can never completely master it.

### What challenges do wedding photographers face?

New photographers will face many challenges entering the wedding market. They need to realize they must run their business in a professional manner, find their creative niche, and create a demand for their services. Great images speak for your talent and enthusiasm, but images alone won't pay your bills. There are many great hobbyists who get paid for their work, but to really grow you have to know what you are doing and get paid what you are worth.

# 8. STACEY KANE

*www.staceykaneweddings.com*

Stacey Kane of Scarborough, ME, photographs weddings, sometimes in exotic locations, as well as children and families, which she does at clients' homes and in her studio during the winter. Before she became a pro photographer, she worked in the wedding industry as a consultant to brides and grooms. She has three children whose pictures she took by the boxful as they grew, and she enjoys the company of a very cooperative husband.

**Describe your background.**

I graduated from the University of New Hampshire as a communications major and, although I'd always enjoyed taking photos, I never considered a photography career. Later when I began photographing my children and others' kids, I discovered I was good at it. In the beginning, I vowed never to do weddings, but now I've been shooting them in journalistic style for about seven years and

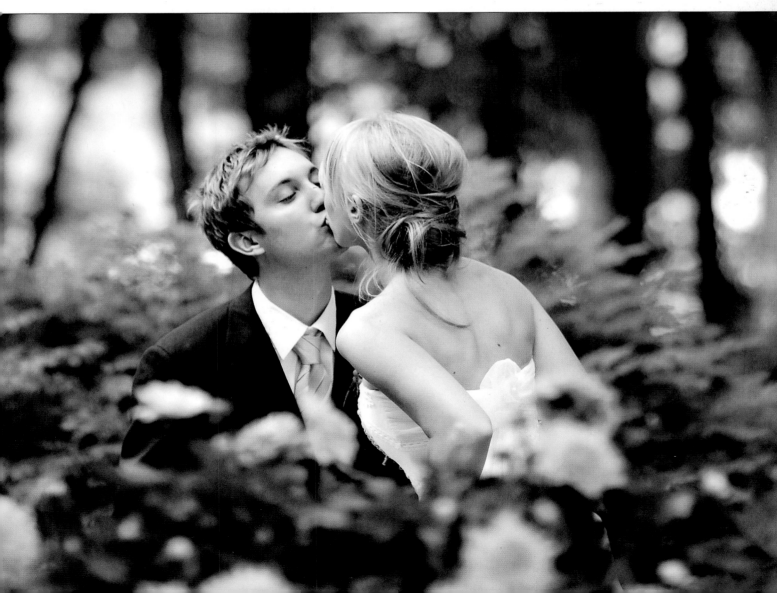

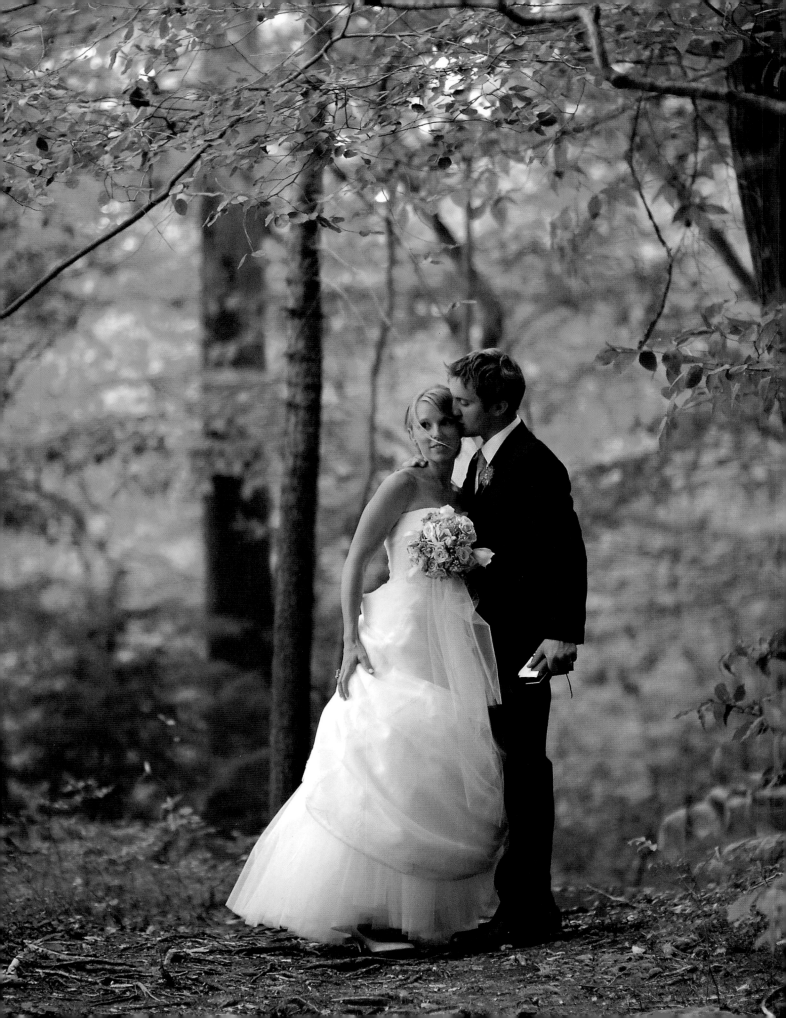

currently spend my time shooting children, families, and weddings.

### How is your career evolving?

I've been in business since 2001. My attitude was, "I'll photograph children and their families, but you'll never catch me photographing a wedding!" But my attitude was interrupted by a couple who had seen my photos of their friends' son. When they asked me to photograph their wedding, I said no, but they eventually wore me down. I loved doing that wedding and I was converted. It didn't take long for word of mouth to take over, and I quickly found myself booked every weekend.

### Who are your influences and mentors?

Initially, my children changed my view and approach to photography. I was never interested in shooting formal portraits of them. I did want to capture who they were at various stages in their lives. The real moments that reveal their personalities are the ones I treasure. Photographing them

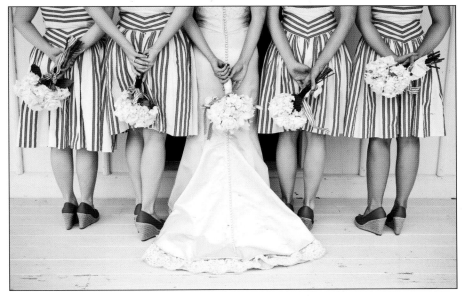

helped me define the way I see events and episodes, and I carried that over into the documentary approach I draw on at weddings.

Because I never studied photography, in the beginning I was not exposed to professional images. Once my career began I found a lot of inspiration from other photographers through online forums like www.ilovephotography.com and www.digitalweddingforum.com. I recommend these sites and others where you meet other photographers offering information, ideas, and a great deal of support.

### Describe your studio.

I have a beautiful studio and gallery space in a former church from the 1800s. I occupy the second floor; on

one side of it there is a meeting area separated from my photography area by a wall. The studio has a cathedral ceiling with original exposed beams. In spite of this beautiful space I still do all of my editing and computer work in my home office where I am simply more productive and focused.

### Do you shoot locally or at more distant locations?

I shoot about the same number of local and location weddings. I consider Maine, New Hampshire, Massachusetts, and Vermont local. Fortunately, more distant destination weddings tend to occur during Maine's cold winter and spring months so it evens out my schedule nicely. I have noticed that there seem to be more destination weddings planned now than there were when I

first started. I don't know if that is actually the case or if I just didn't notice them as much before I started shooting them myself. I also believe that weddings have become more intimate and much more personalized. Again, I don't know if that is actually the case or if it's a result of my growth in the industry.

Since my early days working as a marketing consultant to the wedding industry I have noticed significant variations in how a bride and groom plan their weddings. Most used to meet with a local photographer before hiring him or her, but that seems to have changed. Now couples frequently hire photographers from distant places, and a majority of business transactions occur over the Internet and/or by phone.

I only meet with 10–15 percent of my couples before the actual wedding day. I think the convenience of this shift plays a big role in the popularity of destination weddings.

### How do clients find you?

Either through WPJA (Wedding Photojournalists Association), my web site or blog, or through recommendations. The first thing prospective clients ask about is my availability. If we can coordinate, they check my coverage options and we discuss their preferences.

I actually prefer to not visit a site new to me whether it's local or far away, and I explain to my clients why that is. I love shooting in locations that are new to me. I love the challenges it presents, and I believe that it allows me to be even more creative. I don't want to spend the wedding day working from a "script." I would much rather observe and react to the activities.

### Describe your approach to scheduling sessions.

I handle scheduling, contacts, etc., myself. I'd hire someone to take over business responsibilities, but I have to let go of some of my control issues first! With the exception of some destination weddings, all of my weddings take place on Friday, Saturday, and/or Sunday. I prefer to shoot only one wedding a weekend, but I can book two if they are small and close to one another. In my first full season of weddings I shot three in a row some weekends, and I will never do it again.

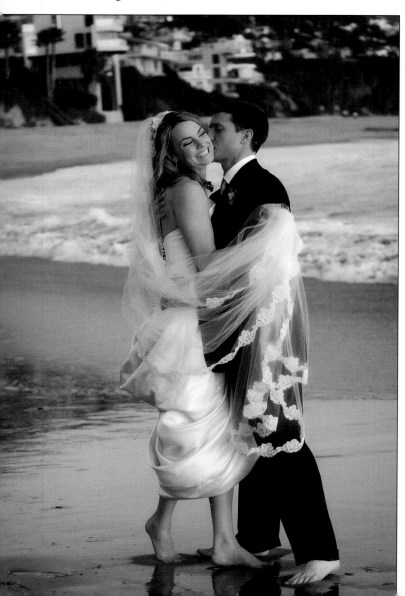

Most of my weddings are booked from six months to a year and a half in advance. I have a giant calendar on my wall where I keep track of all weddings and portrait sessions. Contracts are filed by the month of the weddings. With the exception of occasional family commitments, I am booked every weekend during the wedding season.

### How do you handle retainers and fees?

My current retainer is $1500. I feel this is adequate to confirm a commitment to the contracted date, and it helps maintain a steady income throughout the year since many of my contracts are signed in off-season months. I've never had to return a retainer. A few weddings have been cancelled, but the clients respected the fact that the retainer was nonrefundable.

I offer several different coverage options that vary in products, time allowed, etc. Typically, l begin with the "getting ready" photos if they want them, and I tell them that I'll leave when I have documented everything needed to tell the story of their day. My clients trust that I know when I have enough and don't need to be there

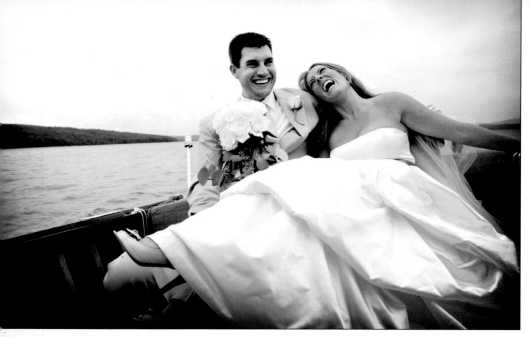

I politely explain that I can't do it. The reason for this is that I don't want anyone to feel I am pressuring them with the threat of someone else taking their date. No client has had a problem signing my contract.

### Do you handle your travel arrangements for location shoots?

I make all my own travel arrangements, online or through my travel agent, depending on the wedding location and whether or not it's at a resort where everyone will be staying.

### What equipment do you favor?

Typically I bring two Nikon D2x cameras, a Fuji S5, and a variety of lenses—a 70–200mm f/2.8, 85mm f/1.4, 28mm f/1.4, 17–55mm f/2.8, 105mm f/2.8, and maybe a fisheye— plus two Nikon SB800s flash units. I try to bring only what I absolutely need, but I do tend to overpack most of the time! You just never know what you may want.

I use on-camera flash when necessary and/or I hold it in my hand, off-camera. I do not use studio strobes.

### Describe your photo timeline.

If the bride and groom have hired a professional wedding planner, I typically consult with that individual about events and timing. Having been to many weddings, I usually know what to expect, but there are variations. I work alone shooting, but I would not be able to do what I do without my husband. I'm always grateful for the responsibilities he takes as a father, which allow me to pursue my career.

I am expected to document the wedding day as it unfolds, so imposing a timeline isn't typically necessary for my clients. I photograph the bride and groom during the preparations and of course at the ceremony, after which we do the group photos, quickly. Depending on the

anymore. Sometimes this means staying until the very end; other times it means when I'm at photo one hundred and twelve of Aunt Edna dancing!

Unless I travel far enough to require an overnight stay, all expenses are included in my coverage. If I need to stay overnight, I charge additionally for transportation, hotels, and meals.

### What is covered in your contract?

Wedding dates are confirmed when I receive a signed contract and the retainer. When I am asked to hold a date or to alert them if someone else is interested in their date,

cocktail hour schedule and/or the lighting at that specific time, I do photos with the bride and groom. Or we join the party and do some shots with them at the tail end of dinner. I prefer to leave things as flexible as possible.

### Do wedding photographers have recognizable styles?

I think that my style developed me! I never really began wedding coverage with a particular style or approach in mind. I just made an effort to shoot events and details the way they presented themselves in an editorial fashion. I have continued to approach weddings in the same way. I don't think that my style is necessarily noticeable. It is primarily documenting the moments and relationships at a wedding. It's capturing real life!

### How have you dealt with unexpected events at the weddings you've photographed?

There are always unexpected happenings at a wedding, and a couple stand out. Recently a severely sprained ankle required me to drive a bride and groom to the local hospital ER. I took pictures until the videographer and I were kicked out due to privacy/confidentiality laws!

Once, at a lake wedding, a furious storm crashed in while I was doing portraits of the bride and groom. They made it under cover, but in an attempt to keep my equipment dry I ended up looking drowned. The guests were all cruising on the lake in a large paddle boat when the storm hit. After several attempts to pick us up we finally made it on board and proceeded to the parents' island property for the reception. There we discovered the power had been knocked

out, and I shot by candlelight for the entire evening. At times I couldn't see through the viewfinder, and I used flash. Thankfully, no one panicked, the food was delicious, and the photos came out great.

### How do you handle your workflow?

The day after the wedding I download all of my memory cards onto my desktop hard drive, and to an external

hard drive. I edit one set in Adobe Photoshop Lightroom, making necessary color corrections, toning, etc., to those that aren't deleted due to closed eyes, being out of focus, etc. I then mark them by category such as getting ready, ceremony, groups, bride and groom, details, and reception using iView. When that is finished, I upload them by category via FTP to Pictage. While they are being processed, I put together a slide show of highlights using ShowIt Web. I upload that to my server and send a link to the bride and groom. I post a few favorites as

well as the slide show on my blog. After they've had a chance to view my wedding choices, I send them a link to their Pictage gallery so they can view all of the images.

### How do you present your images?

I convert some of the images to black & white and leave others for the bride and groom to choose. I am not a heavy editor. I eliminate duplicates and narrow the take down to a point. I leave the final choices to the bride and groom. I feel strongly that it isn't my place to remove a

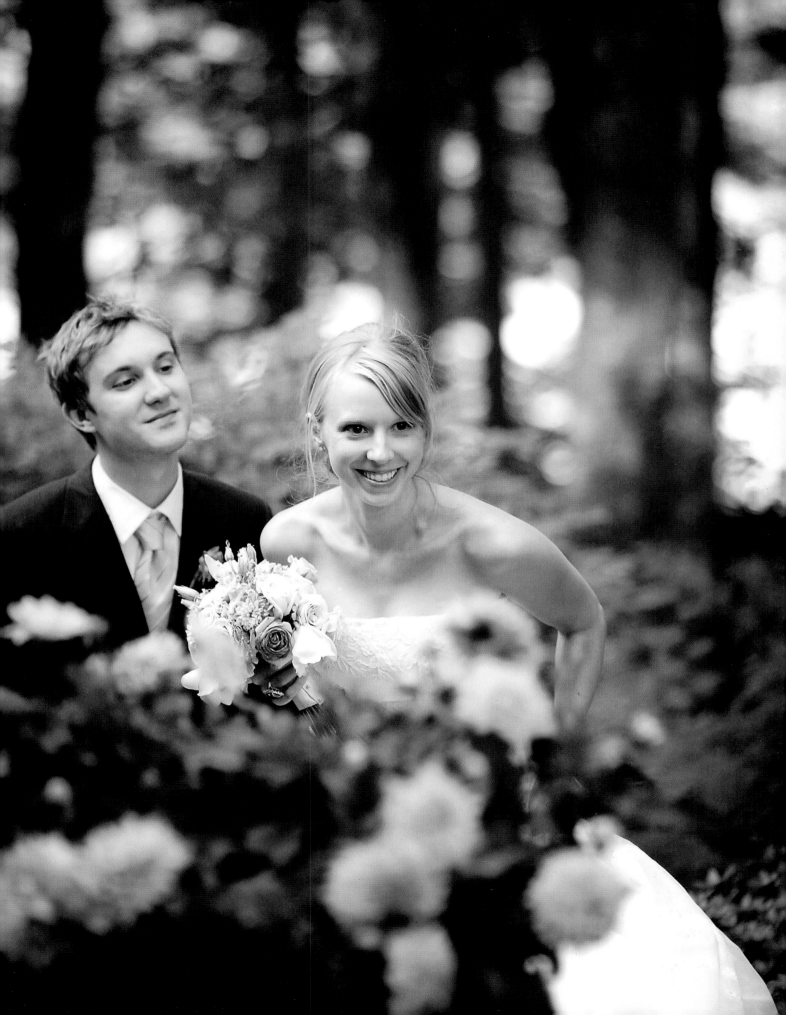

photo of the bride's grandmother just to limit the number of images delivered, or because I feel the lighting isn't perfect. That very photograph could be the one that captures the expression that best represents grandma to the family.

### What do your packages include?

Some of my coverage options include a credit that can be used to order either prints or albums or both. Most of my clients use their credit toward an album. For guests,

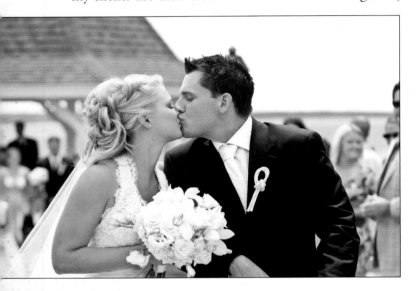

family members, etc., who order prints online, 5x7s and 8x10s seem to be the most popular.

I design some layouts myself and use Pictage designers to do initial layouts for others, then edit them to my tastes. A lot depends on the style of album to be designed, the album company that the books will be ordered from, and the wedding itself. I use Pictage Album Designer and Photojunction for most of my layouts.

### How do you promote your business?

WPJA, Pictage, and word of mouth are my only sources of marketing. WPJA was very helpful in the beginning of my career and continues to play a significant role in my success. I've also had many weddings featured in wedding publications such as *InStyle Weddings, People, US Weekly, Martha Stewart Weddings, Grace Ormonde Wedding Style, Destination Weddings and Honeymoons,* and a few others, and that has been beneficial to my growth.

I believe that word of mouth is vital, from brides and grooms as well as from other wedding photographers and industry leaders. Blogs are also very effective in keeping contacts fresh. My web sites were built by Bludomain, and I do the maintenance and updates, although I admit not frequently enough.

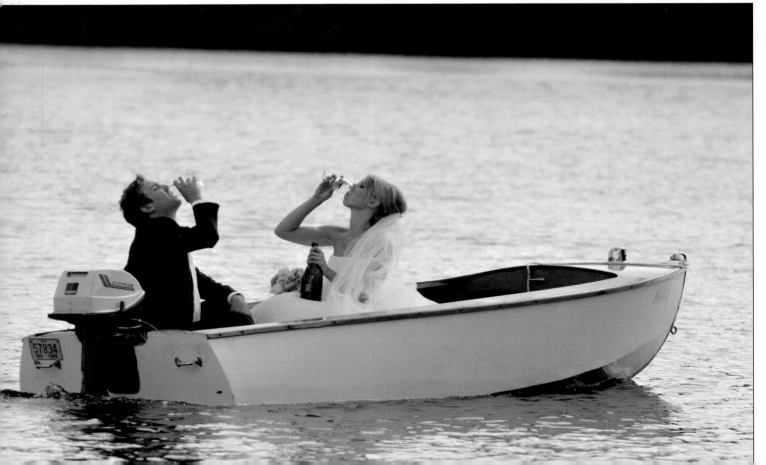

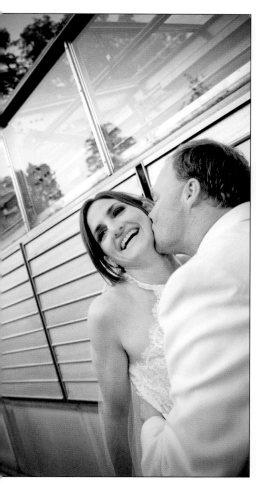

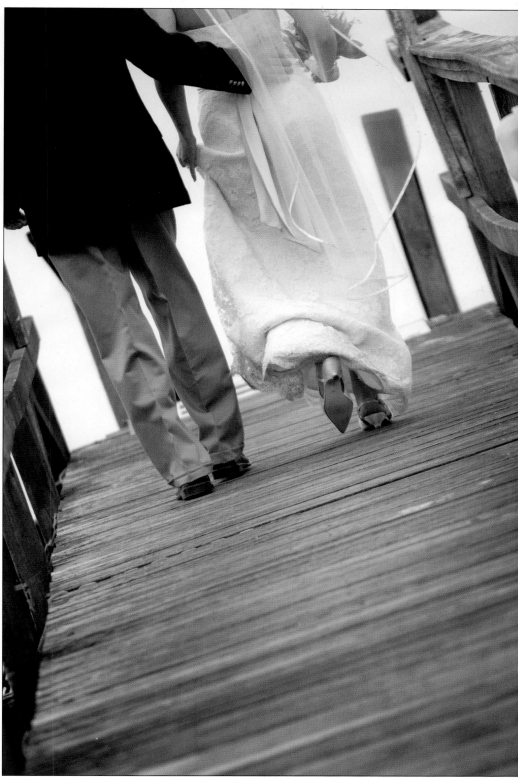

**Is there any business advice you'd like to share?**

One important decision I made early on was not to price myself too low. I believe that many photographers struggle to grow because they do not charge enough when they first start. It's much more difficult to raise prices when you are priced too low than it is to steadily increase them based on demand. I think one reason some photographers fail is that they set prices based on what others in the vicinity are charging instead of by factoring in all of their expenses and deciding how much profit is reasonable for their own business. Understanding business principles is as important as understanding your equipment and programs. It's fun to play with Photoshop and new actions, but you also need a solid business foundation to be successful.

**Is there a philosophy that guides your wedding photography?**

My philosophy is simple: the most important aspects are the images that define the relationships, emotions, and moments of the day for the couple, friends, and families.

### *What challenges do wedding photographers face?*

The biggest challenges are those photographers create by worrying about what others are doing and paying too little attention to their own approach and business. Seminars, forums, and workshops can be very helpful, but they should not detract from giving your best service to clients. You can admire and gain inspiration from other photographers, but you don't have to clone yourself as them. Remain true to yourself and to each job. Focus on what you do best and you will always have work.

# 9. JOHN AND DALISA COOPER

*www.altf.com*

John Michael Cooper and his wife Dalisa operate a distinguished portrait studio called Altf in Las Vegas, NV. John celebrated his twenty-first year in business in 2007 and is Altf's primary shooter. Dalisa is the second shooter and handles business contacts, marketing, etc. She learned all of her photography skills from John. After running the business for a few years, brides requested that she be at the wedding, and Dalisa began shooting. John noticed her strong composition skills, gained in previous work as a graphic designer. Dalisa shoots child portraits alone.

### Describe your background.

*John:* I am self-taught. Earlier I was a computer programmer and systems analyst. My present career started when I dropped out of college and went into photography full time starting in photo labs on the Las Vegas Strip where my experimentation was fueled.

I still shoot images of flowers and dashboards of classic cars for myself. I rarely put the flowers on the dashboards, but keep them separate. I enjoy things that are commonly overlooked.

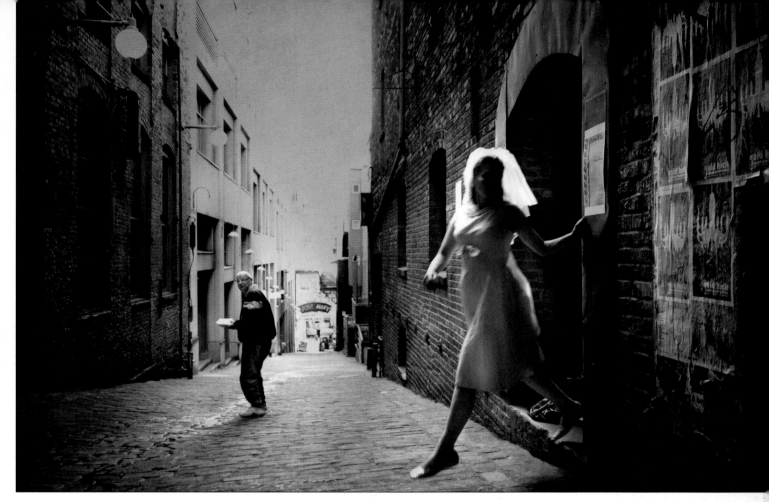

### How has your career evolved?

*John:* I've been in photography on and off for twenty-one years. Altf was born six years ago. I had worked for a studio that specialized in Japanese weddings and was constantly reminded to follow tradition because my pictures would not be "liked." However, each time the client was more than pleased with my style. I had been promised some day to be a partner, but a consequence of 9/11 was being laid off. I was angry and decided I would run my own business, Alt-F Photography. We have since changed it to Altf because it was usually assumed that the *F* stood for fun, fantastic, or foto. I specialized in portraiture and weddings from the beginning since I love to photograph people, and weddings allow me to experiment and refine my portrait skills.

I started out alone and failed because I was continually turned away as too cutting edge. So I worked for a studio doing traditional photography until I was able to evolve back to doing things my own way. Then I met Dalisa, now my wife, who was and is able to run a successful business, and we have prospered. At times we turn away couples if they don't seem a good match for my style. Weddings now take up all my shooting time, and I do portraits on wedding days or during bridal sessions.

### Who are your influences and mentors?

*John:* I was influenced by several Hollywood movie studio photographers, most notably George Hurrell, and later by cinema and MTV. More recently, David Williams has inspired me to look more toward art by the old masters.

I view my wedding day portraits as conceptual. An example is a painting by John Singer Sargent titled *El Jaleo* (circa 1880) portraying a woman in a full gown dancing while background men play guitars. The entire portrait is underlit. So I re-created the scene during a wedding reception, with a bride dancing with background mariachi players. I used flash to light the image from below, a technique I often use on wedding guests dancing.

### Describe your studio.

*John:* We don't need a studio because all photography is on location. We work out of our two-story home. Dalisa's office is upstairs, and I have a separate downstairs

office. (*Aside from Dalisa:* I like my space and independence. Besides, John is unorganized.) In Dalisa's office, there are three workstations. One on her main desk is for production (we use servers to share all image files). The second workstation holds another computer, printer, and all accounting necessities. The third contains a laminator, paper cutter, channel scorer, self-healing mat, and several items to prepare our albums. Dalisa's office also

includes shipping supplies and prints that are ready for production.

*Dalisa:* John's office has two desks, one for two 21-inch monitors, placed side by side, for processing images for the web and client albums. His second desk is in a nook that's hidden by aluminum blinds when clients or guests visit. It holds two external hard drives for back up. There's also a workstation with storage for all of our gear.

Our front room is used for consultations and as a gallery to display our prints and albums.

### Do you shoot locally or at more distant locations?

*Dalisa:* We shoot both. In 2007, we found we were slowly pricing ourselves out of the Las Vegas market and were becoming increasingly popular on the national level.

*John:* I do not follow any of the trends in location weddings or local weddings. I have a very specific clientele that understands at the time of contracting my services that I am not traditional or average.

*Dalisa:* John avoids the safe locations and seeks those not usually noticed by other people. He will avoid the grand staircase and use the side of a building. John is spontaneous when meeting a client or when shooting at

a new location, and generally goes with the couple's energy or passion. He has his own style.

### How do clients find you?

*Dalisa:* When a couple is recommended to us, there are usually fewer questions. They have seen friends' wedding pictures and our web site and know they want us. If they are not planning to meet us, we often set up a phone consultation that I initiate and John takes over. Some clients just hire us via e-mail.

### What's it like to collaborate with your spouse?

*Dalisa:* John is the main shooter and his work is displayed on our web site. Our "D-blog" contains my work. We do not sell ourselves as a team of shooters. At Altf you get John as your photographer and I handle everything else, from contracts and payments, to setting engagement and/or bridal sessions and album details. Clients do meet and deal with John during a consultation and on the wedding day.

If a client decides to add me as a second shooter, I work in a photojournalistic, candid style, which is quite opposite to John's work. When John needs assistance holding a light or rounding up family members, I take care of it. I also do all postproduction, and at this time, we have no employees.

### Describe your approach to scheduling sessions.

*John:* Dalisa handles all client contacts via e-mail or phone.

Sometimes the wedding takes place in a month, sometimes not for a year and a half. It all depends on the availability of the date. We both carry iPhones with a future wedding calendar on them, and we keep files and a database in our computer. We could schedule a wedding every weekend, but we don't because we need leisure time to smell the flowers.

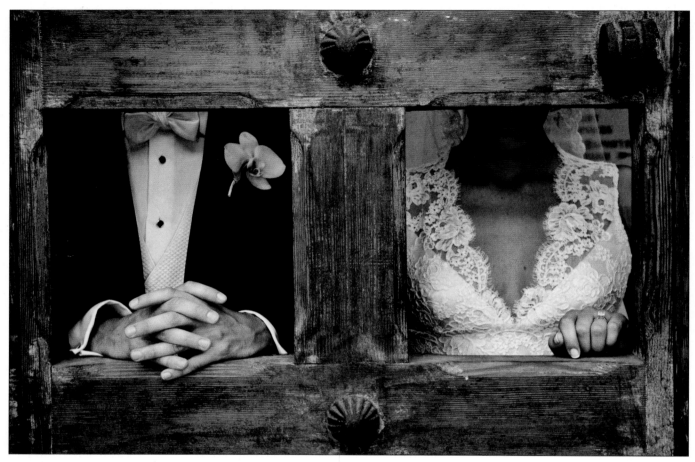

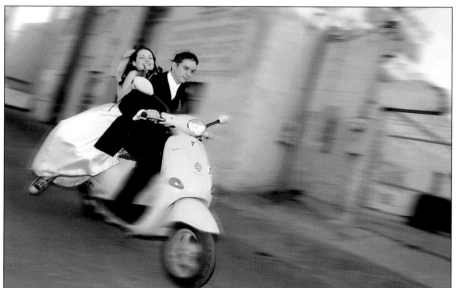

When the couple is impressed by our wedding pictures, the first question they usually have is about price. We explain our wedding day packages, all of which are unlimited in time. If our clients can go the whole day, so can we. Our expenses, such as travel, hotel, and meals, are folded into our fees at the moment, though this may change. Wedding budgets have become larger since we've been in business because the demand for John's shooting style has increased.

We start with a few simple packages covering our time, albums, etc. Our packages become larger, adding in parent albums, engagement sessions, bridal sessions, digital files, and so on. Our top package is our Package Zero, a fine art package designed around the concept of zero client input, allowing the artist to just do his thing. This package is not for the faint of heart. In it the client is guaranteed one forty-

### How do you handle retainers and fees?

*Dalisa:* We do not lock out a date until we receive both a contract and retainer. The retainer is 50 percent of their estimated package cost. The date is then reserved and the retainer is nonrefundable, which is important to our security.

page wedding album, or it could be several volumes depending on the concept of the day. They are also guaranteed the high-resolution digital files.

John has up to fifteen concepts for Package Zero, and no single concept will ever be replicated. This maintains the value of a unique piece of art for the client. Once John completes all fifteen ideas, he will no longer offer Package Zero. That requires a lot of client trust and understanding. They must believe that they will receive an amazing representation of their wedding day.

### What is covered in your contract?

*Dalisa:* The contract defends and limits our liability up to the extent of the fee paid. We will not accept a contract unless the couple has locked in a wedding date with a venue, to avoid date changing. The contract also stipulates that the balance of the fee is due two weeks prior to the event. If the couple cancels the wedding and we can rebook the date, we may negotiate returning a portion of the retainer. Most couples do not question anything in the contract. In a few cases we explain that the contract is necessary to protect both us and them.

### Do you handle your travel arrangements for location shoots?

*John:* For location weddings Dalisa handles travel and hotel reservations. For every wedding I pack all my digital and lighting equipment and a tripod.

Only occasionally do we take time to preview a location before the wedding to be aware of vicinity beaches, woods, meadows, etc. It's usually easy enough to explore spontaneously.

### What equipment do you favor?

*John:* We shoot with both Nikon and Canon cameras. We use a decent range of prime lenses and several zooms. My favorite lens is probably the 50mm f/2. Dalisa's favorite is the 70–200mm f/2.8.

During an average wedding day, we use a mixture of existing light and flash equally, and often use video lights, which are warm and steady. We don't set up studio flash. We also use "deer lights," a nickname for a spotlight that is sold as a utility light and is sometimes used for hunting. I do a lot of painting with light for static portraiture only.

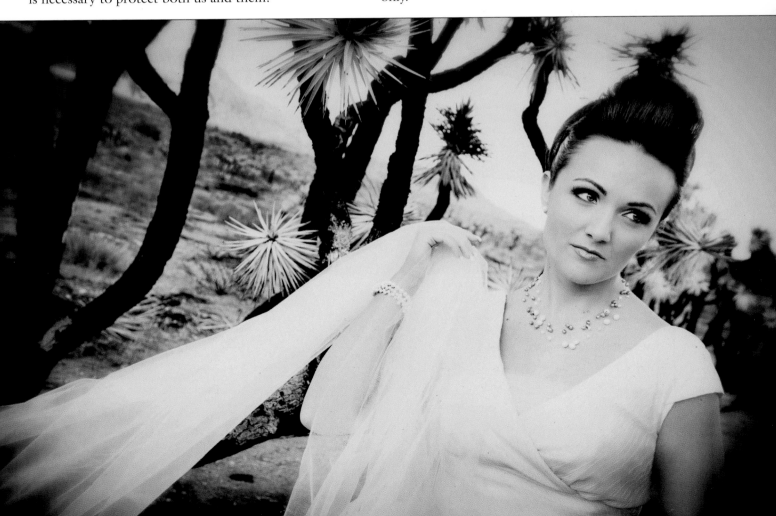

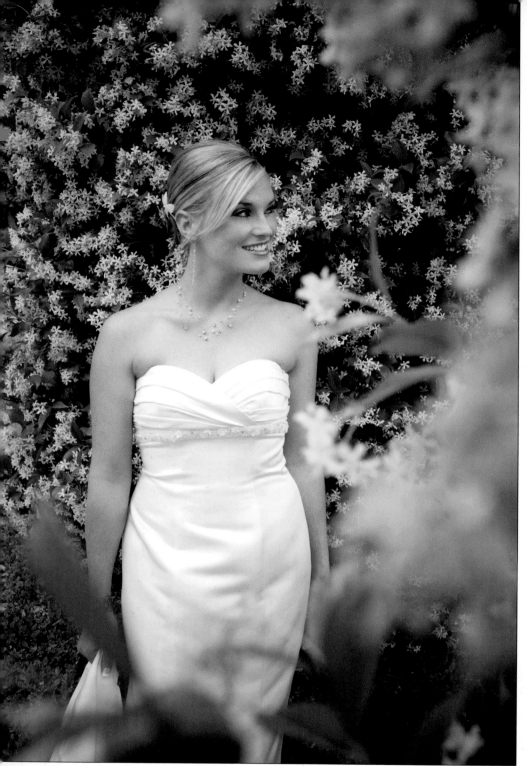

complacency. If the couple asks, I do not hesitate to show them the back of my camera on the wedding day, so they can see what I'm getting. It boosts their excitement. For example, during the end of a wedding a few years back, the guests were handed sparklers to light for the couple to run through. The woman handing out single sparklers from a full basket somehow managed to set the entire bundle in the basket on fire. So just about all the sparklers were used before the couple even made it out of the door, and it made quite a light show, which I photographed.

## Do wedding photographers have recognizable styles?

*John:* I feel that individual artistic approaches can be the mark of a photographer. Even though our pictures please clients and ourselves, it's an advantage if our style is noticeable. Personal style is often what we strive for when we create fine art projects. We want our work to stand out, and we find that we have been quite successful achieving that.

## How do you handle your workflow?

*Dalisa:* After we shoot a wedding, we transfer our memory cards, renumber the images, and sort them into groups, such as getting ready, portraits, ceremony, etc. While adjusting color balance and density, I also edit out images and choose those to retouch and build album pages. From there, I create the client image gallery and album design, and post them online. This process takes two to three days. At this point we have them printed, do the layouts, and hand-bind the albums.

After receiving the prints from the lab, I laminate and trim the pages, then cut the dry-mount tissue and book

## Describe your photo timeline.

*Dalisa:* We do not operate on a timeline. We play everything by ear and fit ourselves into the natural schedule of the day.

## How have you handled unexpected events at the weddings you've photographed?

*John:* I thrive on the unexpected. It allows me to avoid

*Dalisa:* We advertise in magazine print ads and on web sites, but most of our promotion is word of mouth. Recommendations from past brides are very important to us. We maintain our own web site, built for us by Big Folio.

## Are there any business details you'd like to share?

*John:* The most important business decision I made early in my career was realizing that I didn't need to shoot the standard pictures that might have been expected. I could shoot what and how I wanted to, and my business has been based on unusual photographs. We don't review our business plan yearly; we adjust our business approaches when needed. We do pay ourselves salaries.

The most frequent reasons photographers fail in business is overspending unnecessarily, or poor marketing. By just marketing yourself and your product and creating relationships, you will build a good reputation within the industry.

cloth for each album. From there, John takes over and completes the binding. Once the album is completed, it is given to me for shipping. Doing some of these operations saves money, but the primary reason we do the work ourselves is we like the freedom to customize each album if we need to, although most are consistent in size and shape. We can also guarantee quality and eliminate time problems and ordering frustration that we have experienced using outside album producers.

## How do you present your images?

*Dalisa:* We set up an online slide show for each client. Appropriate images are converted to black & white. When we edit pictures, we try to pick only the best to present, and usually deliver about a thousand images to the client's online gallery, selected from fifteen hundred to two thousand shots. This is the average if John shoots by himself. When I shoot as well, the total increases. For example, on a recent weekend between the two of us, we shot thirty-two hundred images in a single day. The client probably received two thousand images, and forty-five to fifty will be put into their book.

Our prints are priced separately from the wedding fee. Most popular are 4x6 and 5x7. We sell any size prints requested, but we do not mat or frame for the client.

## Is there a philosophy that guides your wedding photography?

*John:* Allow outside sources to inspire you in what you do. For example, cinema, fashion, and editorial photography can be inspiring. All photographers are not motivated equally. My enthusiasm is stimulated by constantly experimenting, trying new things, and keeping myself excited about what I do.

## What challenges do wedding photographers face?

*Dalisa:* One of the most important and seemingly obvious challenges is staying on top of the workflow. Most photographers also struggle with business factors like money, communications, etc. So I think it's important to have someone helping you who is good at business and can take over, allowing the artist to just be the artist. Avoiding complacency is another worthy goal.

# 10. CHENIN AND DOUG BOUTWELL

*www.boutwellstudio.com*

Chenin and Doug Boutwell, in wedding photography for six years, have a studio located in Laguna Niguel, CA. Chenin tells clients their website images show exuberant brides and grooms, 100 percent elegant. That's quite a switch for a woman who graduated law school before becoming fully enamored with wedding photography. She says, "Although I do have a very successful business, the art and the people are much more important to me than the money." Chenin was interviewed for this chapter.

### Describe your background.

I have no formal education in photography though I was very creative as a kid. I studied political science at the University of California–Irvine with an emphasis on women's studies, and planned to go into politics. The more I thought about the lifestyle, the more I realized that being a politician was not for me. After college I was offered a full scholarship to Chapman University School of Law. That summer, when Doug and I got married, we

were really disappointed in the wedding photographers we met.

Doug studied a bit of photography in college and taught me what he knew. With that, we started shooting weddings for friends and acquaintances, and by the time I started law school we had created a full-fledged photography studio! I continued to shoot weddings to pay my way through law school and received my J.D degree but did not take the bar exam. I decided that I loved photography too much to hang it up, and I've never regretted the decision.

I do some personal photography work, and I prefer to shoot film for those projects. I shoot Holgas and Polaroids, and occasionally Doug lets me play with the large format cameras. For me, it's really mental separation because I shoot digital SLRs for work. I don't even shoot digital on vacation. We take an old Polaroid SX-70, a model my grandfather helped design!

As our business grew, Doug and I discovered that we each loved different things about weddings. I loved their fast-paced, unexpected nature, and Doug preferred the more low-key and measured portrait photography. In 2007, Doug left our business to pursue more editorial and assignment work. He is still headquartered at our studio, and I have taken over the wedding business.

### How is you career evolving?

Weddings are my primary focus. A few years ago I also did more portrait work, but now I don't solicit it separately. I shoot about thirty-five to forty-five weddings a year, and about twenty-five engagement sessions for my wedding clients. As our wedding business grew, Doug

worked on our Photoshop actions, but I do my own Photoshop work now and use the actions Doug developed (www.totallyradactions.com).

## Who are your influences and mentors?

I avoid looking at wedding photography. I think one big mistake wedding photographers make is to look at other wedding photos and albums for inspiration. I feel that may lead to a pedestrian and homogenous pool of wedding pictures and shooters.

We subscribe to numerous fashion magazines, and that's not just because I love designer shoes!`I look at Annie Liebovitz for inspiration when shooting groups, and Michael Thompson and Herb Ritts for portraits. I love David LaChapelle's color and Sally Mann's black & white photography. I am also quite inspired by the spon-

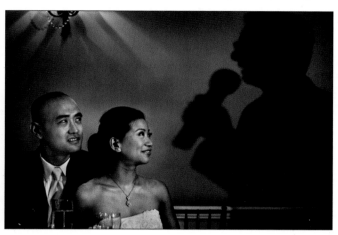

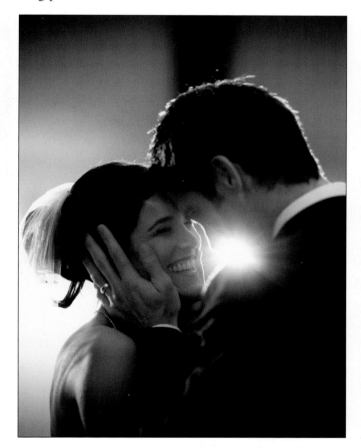

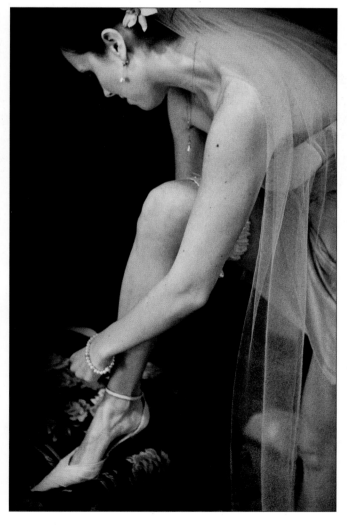

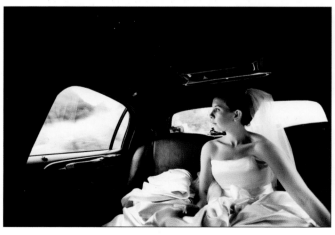

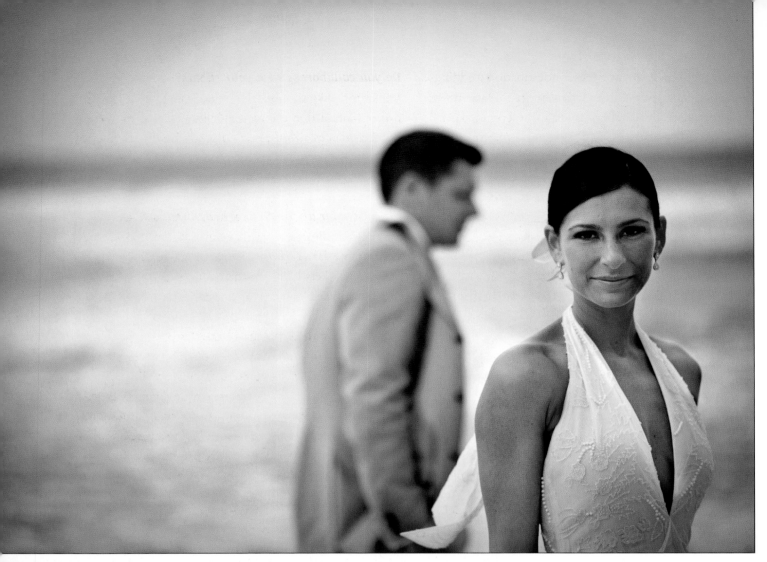

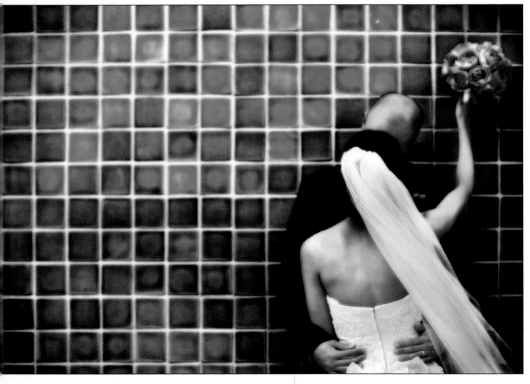

taneity of Magnum photographers. I use the photo layouts in books and magazines to inspire my album designs.

### Describe your studio.

My wedding business is run out of an 800-square-foot studio used for workflow production and meeting space, but I only do location shoots. I also have a small office at home, plus a shooting studio for Doug.

### Do you shoot locally or at more distant locations?

I shoot wherever clients want me. About 90 percent of my weddings are in Southern California, but I travel farther several times a year. I charge

hefty minimums and travel fees for destination weddings, as I can usually shoot only one that weekend. Destination weddings have definitely become more commonplace, but there is intense competition among photographers to book them in many venues. I feel that having a destination portfolio has become more of a status symbol, and some photographers are willing to shoot in distant locations for cheap, or even free. Higher-priced shooters face considerable competition for choice jobs. I take a second shooter with me to most weddings.

I do not visit locations before local weddings. I have learned over the years that what really matters is the light, and I can't duplicate that on a pre-wedding visit.

## How do clients find you?

Almost all of my business is based on referrals from past clients, bridal consultants, or venues, like hotels. It is rare that someone finds and books me online. However, my web site is an essential tool in booking brides, because it's where they see their friends' albums, or a sample album. By the time they meet with me, they are sold.

## Do you collaborate with your clients?

I am very lucky that most of my clients let me do whatever I want. I don't accept shot lists nor guarantee any specific images. I tell brides that my best work is done when I have complete creative control, and most of them willingly give it. They realize I'm the expert.

## Describe your approach to scheduling sessions.

I accept weddings as early as eighteen months in advance, including a large minimum package, but most of my clients book between nine and twelve months out. I keep track of booked dates on a calendar.

## How do you handle retainers and fees?

I charge a $2000 retainer fee, which becomes immediately nonrefundable. This is made clear to clients.

I offer a list of packages from which clients choose. It starts with six hours' coverage and a small album, and proceeds to ten hours and several albums. The fees include expenses for local weddings, but for weddings outside of Orange County, CA, I add a travel fee to the

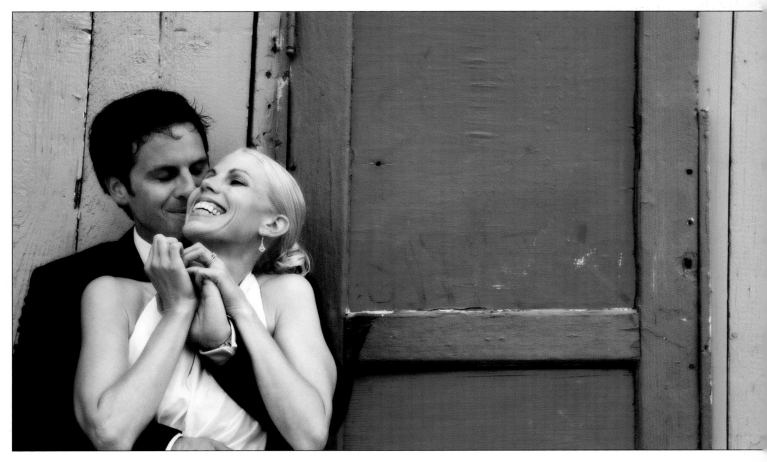

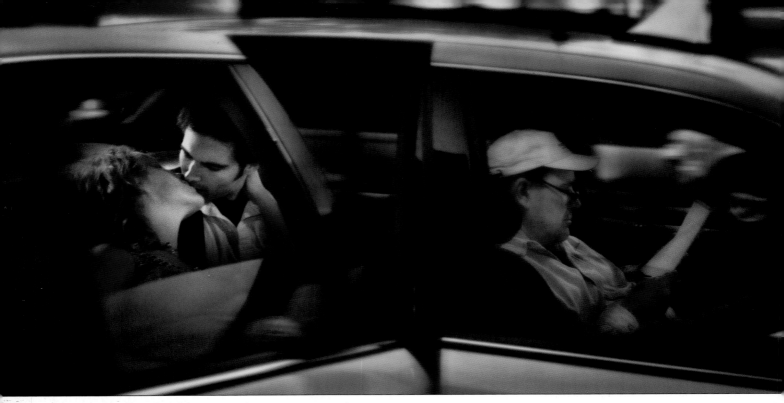

packages. This covers airfare, hotel, food, and ground transportation for two photographers. I do not accept smaller weddings that only require a few hours' coverage. They must book my minimum package, regardless of the size or duration of the wedding.

### What is covered in your contract?

Because of my legal background, I take contracts very seriously. Our contract is three full pages, in a ten-point font. It does occasionally intimidate people, but I try to discuss each term with them.

The most important items to include in a contract are:

- a complete and detailed inventory of what is included in the package
- the exact amount and due dates of each payment

- what happens if they don't pay
- a clause that limits your liability in the event that something or someone prevents you from getting your shots
- a copyright clause that reaffirms that you own the copyright and may grant reproduction rights to the client
- a model release that allows use of the images for all purposes, including stock, competition, and sales materials
- a clause explaining that a cancellation must be in writing and that all monies paid to that point are nonrefundable
- a clause that limits the photographer's obligation to store the photographs
- a clause stating that future orders are at prevailing prices at the time of booking
- a clause that explains your position on color accuracy, permanence, and general quality of materials.

Only occasionally does someone balk at sections of my contract, but I never negotiate the terms. The exception is the model release for clients considered high-profile.

### How do you handle your travel arrangements for location shoots?

For destination weddings, I usually make my own travel

arrangements, except for very un-familiar places, when I use a travel agent.

## What equipment do you favor?

We carry camera gear for myself and an assistant plus backups, but usually no studio lighting. A typical combi-nation of gear would be: Two Canon 5Ds each, plus lenses, usually a 17–40mm, 24mm, 24–70mm, 50mm, 85mm, 85mm shift/tilt, and a 70–200mm. Flash units and cases are also included.

If I cannot shoot with available light, which I prefer, I use flash, most often on-camera, with no diffusion. I am careful to use a slow shutter speed to include ambient light. Direct flash has gotten a bad rap, but I feel it can look very high-energy, colorful, and vibrant when used properly. At a re-ception I don't set up studio lights be-cause they would be a distraction.

## Describe your photo timeline.

I do not create a timeline. It's the couple's wedding, and it's my job to make it work. But I do request a writ-ten timeline from the couple before the wedding, and I've asked a bride to revise it to allow more photography time. Mainly, I use the time they're willing to give, and I make it work.

## Do wedding photographers have recognizable styles?

I definitely think that wedding pho-tographers can develop a recognizable style. Clearly, not every image they shoot will match up to that style, be-cause there are so many aspects to work with at a wedding. But with a sensitive visual approach, consistent

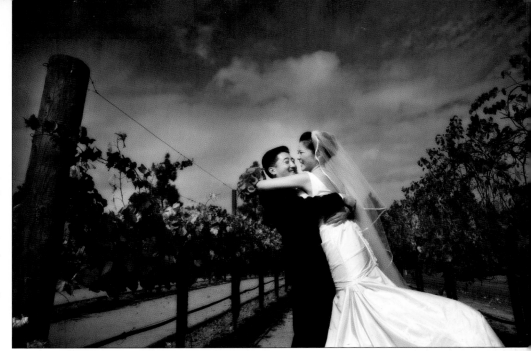

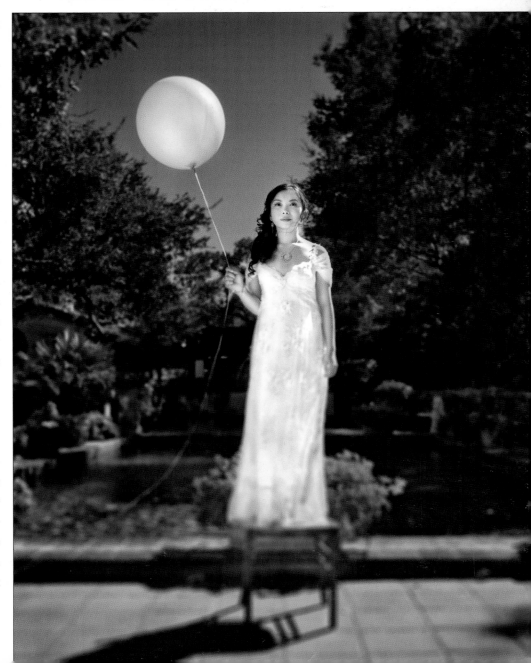

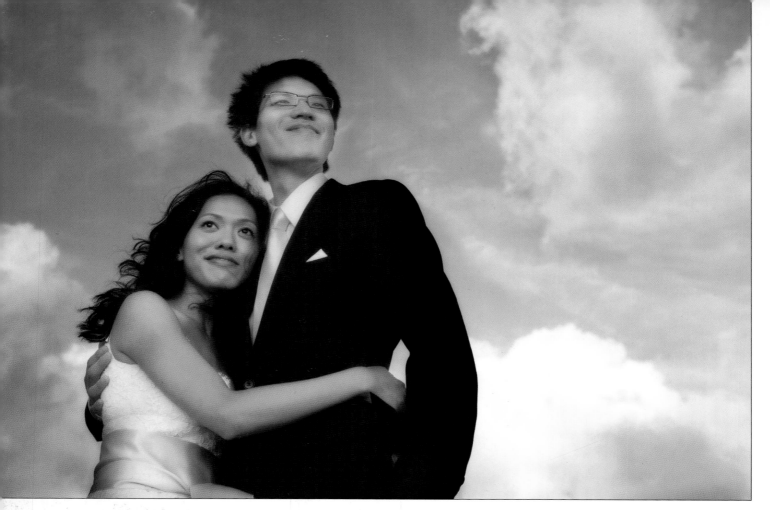

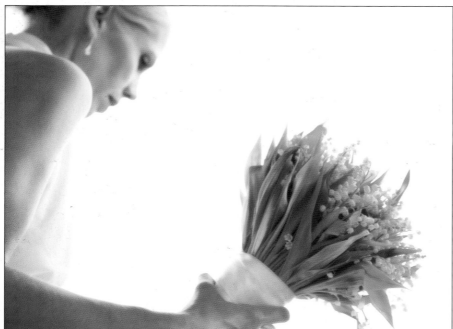

certainly make them and include them in a clients' proofs. It's just not the approach that I choose to emphasize. So it's all about the picture editing and attitude.

I do think having a recognizable style is important. Let's say a bride and groom tell their wedding coordinator they are looking for fun, funky, energetic photography, so the coordinator refers them to me, because that's how she interprets my style. The client books, and my "style" pays off.

### Do you have any insights for dealing with the unexpected?

The unexpected is what weddings are all about! I try very hard to go with the flow and let things unfold as I document them. Sometimes, though, the universe works against you. A favorite example happened at a large wedding, with probably three hundred guests, that Doug and

postproduction work, and good editing, wedding photographers can develop a style. Keep in mind that much of "style" is determined by which images we show and how we show them. For example, I am not particularly known for soft, feminine, or romantic images, though I

I photographed. All of the guests had cameras (or so it seemed), mostly professional bodies and lenses. People literally hid in bushes and climbed trees to photograph the bride and groom. At first we were irritated, but we reminded each other that our job is to document the day, and rampant guests with cameras were part of it.

Doug ran around and shot character portraits of guests with their cameras, and I started to work with them. I juxtapose a guest with a camera in a shot of the bride and groom having a special moment. I snapped images of the bride coming down the aisle with a wide lens to show how excited guests photographed her and her father. We even shot the first kiss through the LCD of a guest's camera! It ended up being one of my favorite weddings that year. By embracing the unexpected, we showed how unique their wedding was.

## How do you handle your workflow?

It's not easy to process sixty shoots a year by yourself, so I have a darn good workflow system. I download, renumber, and back up the originals to a DVD. Then I choose only images I want to present to the client. I process those raw images in Adobe Photoshop Lightroom, correcting color, exposure, and white balance. After I have a set of JPEGs, I generate a proof book and an online gallery for the client. I back up the JPEGs to a hard drive and delete the originals from the server. Once I have proofed the images, I do a second edit during which I select images for the album.

I rework those images in Photoshop, using actions that Doug has developed over the years and design an album for the client. All of my albums

are designed free hand in Photoshop. I never use designers or templates. The enhanced images are saved in a separate directory to be used for vendor promotion and sample material. I proof the album to the client using an

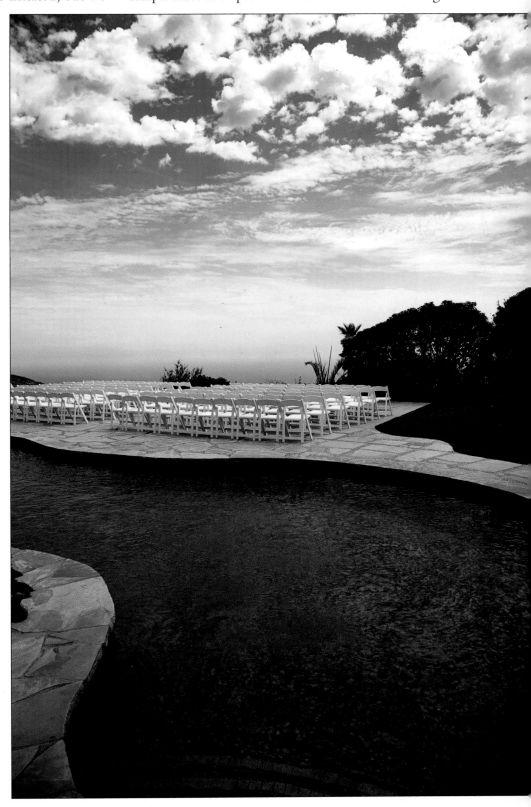

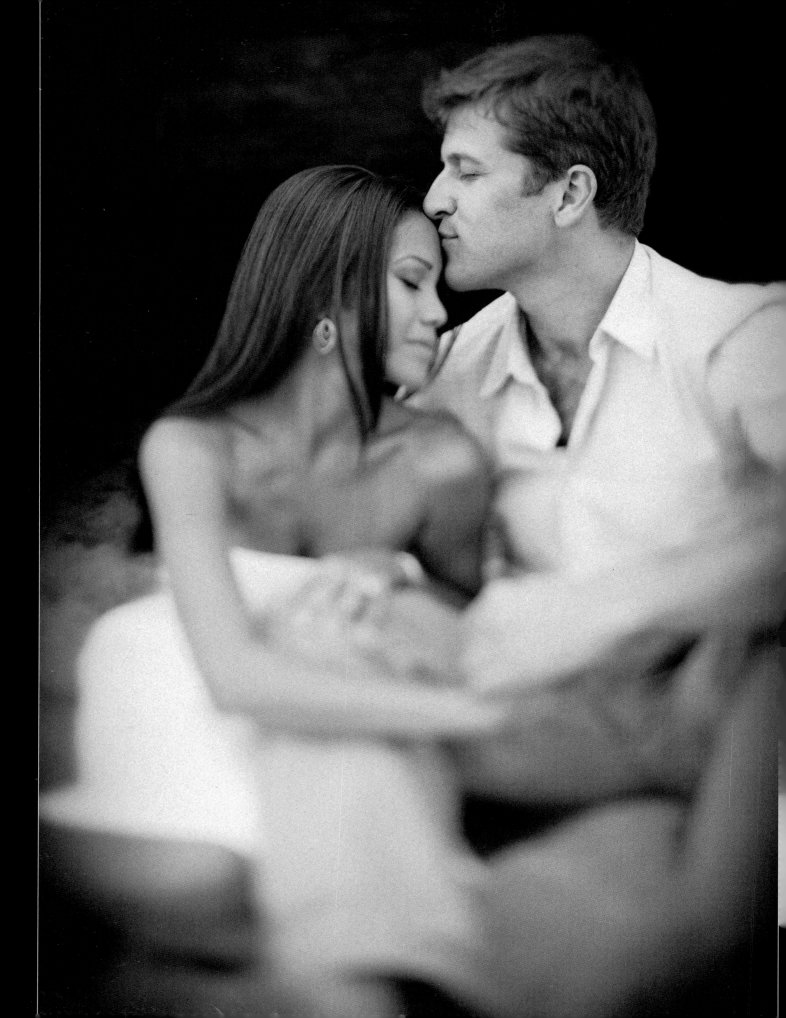

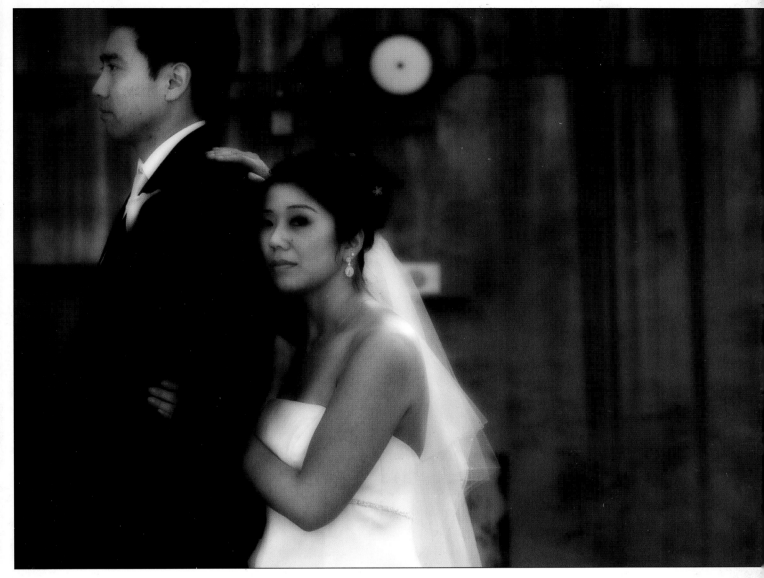

online proofing system, and they submit changes to me. I make the changes and after final approval, the album is printed and bound.

Typically, the client's proofs go online within one week of the wedding, and I present an album proposal within one month. Most of my clients have a finished album three months after their wedding.

### How do you present your images?

Clients see their images for the first time on my blog. Their full set of proofs is posted online shortly after that, and they receive their proof book a few weeks later. I capture in color and convert a select number of images to black & white at my discretion. I usually proof five hundred to seven hundred images.

### What do your packages include?

Prints are not included in the packages. Clients can order prints on my web site and drop them into a shopping cart. Usually, people order smaller prints for frames around the house and invest in one or two large art prints.

### How do you promote your business?

I invest a lot of time honing relationships with other wedding professionals, and as a result, most of my bookings come from word of mouth. However, my web site is incredibly important because it's the first contact a client has with my work. The site is maintained by a very skilled web-design team.

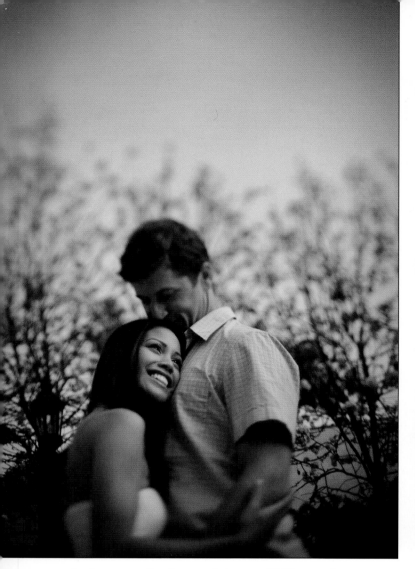

### Is there any business advice you'd like to share?

The most important business decision we ever made was to be true to ourselves. It made questions about branding, identity, and our target market much easier to answer. We do not have a formal business plan, though I feel one could benefit many photographers. Though I have a very successful business, the art and the people are more important to me than the money. I shoot weddings and provide clients with opportunities to buy only the items that I feel will benefit them. My salary allows opportunities for savings, investments, and even some fun!

### Is there a philosophy that guides your wedding photography?

I know that weddings are an incredibly important event in a family's life, but I don't tend to make a fetish of them. They're an event, like going to a baseball game, or having a birthday, and that's how I like to approach them. If I get too tangled up in the fancy white dress,

the flowers, and the etiquette, I start to shoot what's "expected" and not what's happening. Weddings provide an amazing opportunity to photograph people, emotions, and happenings, all at once. I always try to be aware that it's not about any one thing, it's about the entire experience. That said, I am sentimental, and I tend to shoot from my heart more than my head.

### What challenges do photographers face?

I think the most important challenge is to remain fresh. All the competition, emerging technologies, and ease of entry into the profession are irrelevant if you're a fresh, inspired photographer creating kickin' work. The trick is being inspired to make amazing images at every wedding, even if you're tired, or the bride isn't hot, or the details suck. It's about knowing that you can approach any shoot and come out with awesome work. If you can do that, competition is no big deal.

# INDEX

## *Select books by Lou Jacobs Jr. . . .*

### PROFESSIONAL CHILDREN'S PORTRAIT PHOTOGRAPHY

Fifteen top photographers reveal their most successful techniques—from working with uncooperative kids, to lighting, to marketing your studio. $34.95 list, 8.5x11, 128p, 200 color photos, index, order no. 2001.

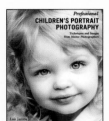

### PROFESSIONAL PORTRAIT PHOTOGRAPHY
TECHNIQUES AND IMAGES
FROM MASTER PHOTOGRAPHERS

Veteran author and photographer Lou Jacobs Jr. interviews ten top portrait pros, sharing their secrets for success. $34.95 list, 8.5x11, 128p, 150 color photos, index, order no. 2003.

### PHOTOGRAPHER'S LIGHTING HANDBOOK

Think you need a room full of expensive lighting equipment to get great shots? With a few simple techniques and basic equipment, you can produce the images you desire. $29.95 list, 8.5x11, 128p, 130 color photos, order no. 1737.

### STUDIO LIGHTING
A PRIMER FOR PHOTOGRAPHERS

Get started in studio lighting. Jacobs outlines equipment needs, terminology, lighting setups and much more, showing you how to create top-notch portraits and still lifes. $29.95 list, 8.5x11, 128p, 190 color photos index, order no. 1787.

### SOFTBOX LIGHTING TECHNIQUES
FOR PROFESSIONAL PHOTOGRAPHERS

*Stephen A. Dantzig*

Learn to use one of photography's most popular lighting devices to produce soft and flawless effects for portraits, product shots, and more. $34.95 list, 8.5x11, 128p, 260 color images, index, order no. 1839.

### JEFF SMITH'S LIGHTING FOR OUTDOOR AND LOCATION PORTRAIT PHOTOGRAPHY

Learn how to use light throughout the day—indoors and out—and make location portraits a highly profitable venture for your studio. $34.95 list, 8.5x11, 128p, 170 color images, index, order no. 1841.

### PROFESSIONAL PORTRAIT POSING
TECHNIQUES AND IMAGES
FROM MASTER PHOTOGRAPHERS

*Michelle Perkins*

Learn the strategies master photographers use to pose their subjects and create unforgettable images. $34.95 list, 8.5x11, 128p, 175 color images, index, order no. 2002.

MONTE ZUCKER'S
### PORTRAIT PHOTOGRAPHY HANDBOOK

Acclaimed portrait photographer Monte Zucker takes you behind the scenes and shows you how to create a "Monte Portrait." Covers techniques for both studio and location shoots. $34.95 list, 8.5x11, 128p, 200 color photos, index, order no. 1846.

### DIGITAL PHOTOGRAPHY FOR CHILDREN'S AND FAMILY PORTRAITURE, 2nd Ed.

*Kathleen Hawkins*

Learn how staying on top of advances in digital photography can boost your sales and improve your artistry and workflow. $34.95 list, 8.5x11, 128p, 195 color images, index, order no. 1847.

### JEFF SMITH'S POSING TECHNIQUES FOR LOCATION PORTRAIT PHOTOGRAPHY

Use architectural and natural elements to support the pose, maximize the flow of the session, and create refined, artful poses for individual subjects and groups—indoors or out. $34.95 list, 8.5x11, 128p, 150 color photos, index, order no. 1851.

## MASTER LIGHTING GUIDE
### FOR WEDDING PHOTOGRAPHERS

*Bill Hurter*

Capture perfect lighting quickly and easily at the ceremony and reception—indoors and out. Includes tips from the pros for lighting individuals, couples, and groups. $34.95 list, 8.5x11, 128p, 200 color photos, index, order no. 1852.

## POSING TECHNIQUES
## FOR PHOTOGRAPHING
## MODEL PORTFOLIOS

*Billy Pegram*

Learn to evaluate your model and create flattering poses for fashion photos, catalog and editorial images, and more. $34.95 list, 8.5x11, 128p, 200 color images, index, order no. 1848.

## THE ART OF
## PREGNANCY PHOTOGRAPHY

*Jennifer George*

Learn the essential posing, lighting, composition, business, and marketing skills you need to create stunning pregnancy portraits your clientele can't do without! $34.95 list, 8.5x11, 128p, 150 color photos, index, order no. 1855.

## ILLUSTRATED DICTIONARY
## OF PHOTOGRAPHY

*Barbara A. Lynch-Johnt & Michelle Perkins*

Gain insight into camera and lighting equipment, accessories, technological advances, film and historic processes, famous photographers, artistic movements, and more with the concise descriptions in this illustrated book. $34.95 list, 8.5x11, 144p, 150 color images, order no. 1857.

## EXISTING LIGHT
### TECHNIQUES FOR WEDDING AND PORTRAIT PHOTOGRAPHY

*Bill Hurter*

Learn to work with window light, make the most of outdoor light, and use fluorescent and incandescent light to best effect. $34.95 list, 8.5x11, 128p, 150 color photos, index, order no. 1858.

### THE SANDY PUC' GUIDE TO
## CHILDREN'S PORTRAIT
## PHOTOGRAPHY

Learn how Puc' handles every client interaction and session for priceless portraits, the ultimate client experience, and maximum profits. $34.95 list, 8.5x11, 128p, 180 color images, index, order no. 1859.

## MINIMALIST LIGHTING
### PROFESSIONAL TECHNIQUES FOR LOCATION PHOTOGRAPHY

*Kirk Tuck*

Use small, computerized, battery-operated flash units and lightweight accessories to get the top-quality results you want on location! $34.95 list, 8.5x11, 128p, 175 color images and diagrams, index, order no. 1860.

## SIMPLE LIGHTING
## TECHNIQUES
### FOR PORTRAIT PHOTOGRAPHERS

*Bill Hurter*

Make complicated lighting setups a thing of the past. In this book, you'll learn how to streamline your lighting for more efficient shoots and more natural-looking portraits. $34.95 list, 8.5x11, 128p, 175 color images, index, order no. 1864.

### PHOTOGRAPHER'S GUIDE TO
## WEDDING ALBUM
## DESIGN AND SALES, 2nd Ed.

*Bob Coates*

Learn how industry leaders design, assemble, and market their outstanding albums with the insights and advice provided in this popular book. $34.95 list, 8.5x11, 128p, 175 full-color images, index, order no. 1865.